The Acrylic
Artist's Bible

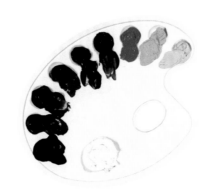

The Acrylic Artist's Bible

An essential reference for the practising artist

Marylin Scott

Search Press

A QUARTO BOOK

ISBN: 978-1-78221-395-6

Conceived, designed and produced by
Quarto Publishing plc
The Old Brewery
6 Blundell Street
London N7 9BH
www.quartoknows.com

QUAR.AABX

Senior Editor: Trisha Telep
Art Editor: Tania Field
Designer: Jill Mumford
Assistant Art Director: Penny Cobb
Picture Researcher: Claudia Tate
Photographer: Martin Norris
Proofreader: Louise Armstrong

Creative Director: Moira Clinch
Publisher: Paul Carslake

Colour separation by Provision
Pte Ltd., Singapore.
Printed in China

Parts of this book have previously been published
in *The Encyclopaedia of Acrylic Techniques*,
100 Great Acrylic Painting Tips and *The Acrylic
Painter's Pocket Palette*.

Contents

Techniques 68

Subjects 150

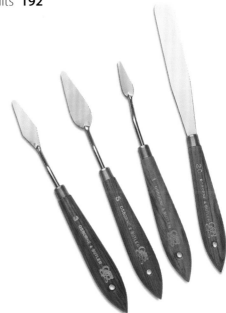

Introduction

Acrylic is the newest of all the painting mediums, having only been invented in the mid-20th century. It is widely used by professional artists, but is less popular with amateur painters, which is a pity, because it is a wonderfully versatile medium capable of achieving a vast range of different effects. It may be this very quality that puts people off – when there are so many possibilities, it can be difficult to decide just how to start. But with *The Acrylic Artist's Bible* at hand, you have all the help and advice you need – it's a must-have for anyone new to the medium, and even those who have used acrylic before will find some new ideas and inspiration.

The book is divided into four sections. The first, Choosing and Using Materials, contains helpful advice on the paints and equipment you will need to make a start, as well as providing tips on preparing your own boards and canvases.

The second section, Colour, explains some of the basic properties of colour, showing ways of mixing colours, either on a palette or on the working surface, and provides essential advice on choosing a 'starter palette'.

▲ Learn about tools and materials

The third section, which forms the core of the book, presents the exciting range of techniques available to the acrylic painter. The chapter begins with a demonstration of three different ways of building up a painting from an initial sketch through to completion, so if you have not tried acrylics before, use these as your starting point. You will then be introduced to more unusual methods, all of which are fun to try out, so if you have not tried painting with knives, scratching into paint, squeezing paint on with an icing piper, building up exciting textures or glazing over an underpainting, here is your chance. All the techniques are shown as a series of clear step-by-step

▶ Build a basic palette

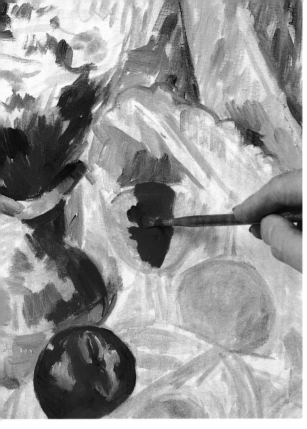

◄ **Discover new skills** demonstrations done by a carefully selected group of professional artists, with captions explaining what to do at each stage. In the final section, Subjects, you will see the techniques in action. Finished paintings by a wide range of well-known acrylic painters illustrate the amazing diversity of styles possible with this wonderful medium, while text and captions provide hints on composition and uses of colour. As an added bonus, there are two specially commissioned Tutorials, which enable you to follow an artist's progress from the planning of the picture through to completion. This section is intended to help you learn by example; looking at other people's work is an essential part of any artist's learning curve, and you may find that it helps you towards establishing your own style.

But the most important aspect to being an artist is to enjoy what you are doing, and to be willing to experiment with ideas and methods, so treat this book as a springboard to launch you into the exciting world of painting with acrylics.

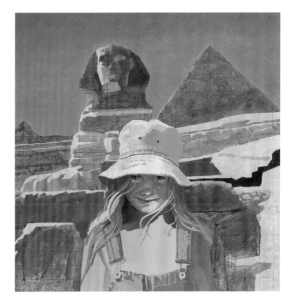

► **Look at paintings by established artists**

1
Materials

Introducing acrylics

Acrylic paints are a by-product of the plastic industry, just like the emulsion paint we use on our walls. The pigments used for acrylics, with a few exceptions, are the same as those used for oils, watercolours and pastels; what makes them different is the binder, which is a polymer resin. This, once dry, acts as a form of plastic coating that cannot be removed.

Because the paints are water-based, they are thinned by mixing with water or with a combination of water and one of the many mediums specially made for the purpose (see page 20). With acrylics, you can paint in any consistency you like, which gives these paints what is perhaps their greatest virtue: amazing versatility. You can use them in thin washes resembling watercolour, or apply colours with a knife in thick slabs. You can use thick paint in one part of a picture and thin in another; you can build up an infinite variety of textures; and you can employ traditional oil-painting methods such as glazing – much easier in acrylic than in oil.

Painting sets

Several manufacturers offer introductory sets that include a range of pre-selected colours and, occasionally, different acrylic mediums, brushes and palettes – all contained in either simple packaging or a tailor-made wooden box. These sets can be an expensive way to sample acrylics, and also the colours may not be to your liking, so it is usually better to purchase a few tubes and brushes separately.

Students' colours

Acrylics, like most other paints, are produced in two versions, students' and artists'. The former contain less pure pigment to the proportion of filler, making some of the colours slightly less intense, and the range of colours is smaller than the artists' colours. However, most are of very good quality, and being considerably less expensive than artists' colours, are ideal as an introduction to the medium.

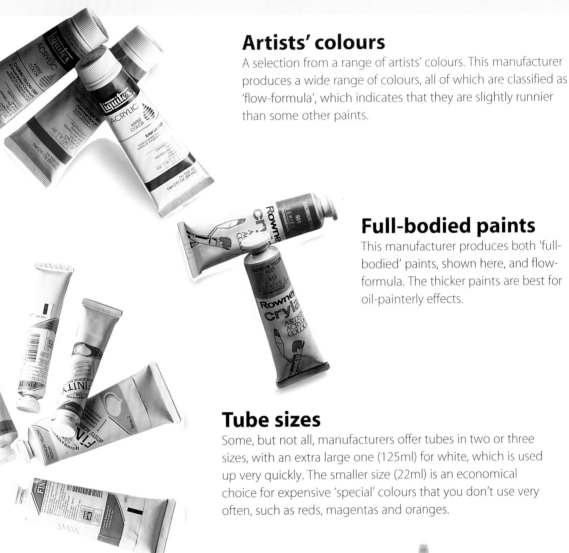

Artists' colours

A selection from a range of artists' colours. This manufacturer produces a wide range of colours, all of which are classified as 'flow-formula', which indicates that they are slightly runnier than some other paints.

Full-bodied paints

This manufacturer produces both 'full-bodied' paints, shown here, and flow-formula. The thicker paints are best for oil-painterly effects.

Tube sizes

Some, but not all, manufacturers offer tubes in two or three sizes, with an extra large one (125ml) for white, which is used up very quickly. The smaller size (22ml) is an economical choice for expensive 'special' colours that you don't use very often, such as reds, magentas and oranges.

Paint pots

Pots, which are usually slightly more fluid than tubed paints, are useful for large-scale studio work, but even the smaller sizes are less portable than tubes, so they are of limited use for outdoor sketching. If you do use them, avoid dipping the brush directly into the paint, since you will pollute the colour if the brush is not perfectly clean.

Liquid acrylics

Liquid-acrylic colour, which is slightly more expensive than tube acrylics, resembles ink or liquid watercolour. It is available in bottles with standard screw tops, and most bottle tops contain a dropper for transferring paint onto the palette. Liquid acrylics can be used in much the same way as ink and watercolour. Because they are made using an alkali resin, they can be softened and removed from pens and brushes with a preparatory alkali cleaning fluid.

These paints are good for painting in 'watercolour mode', and work better than diluted tube colours. However, they are no substitute for true watercolour, and cannot be manipulated on the painting surface because they dry too fast.

Acrylic inks

Inks can be used in combination with acrylic paints, and are popular with artists using mixed-media approaches. The pearlescent inks shown here produce an attractive shimmering effect.

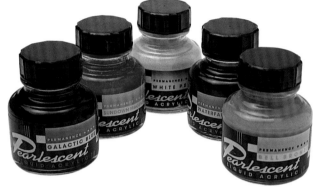

Acrylic inks

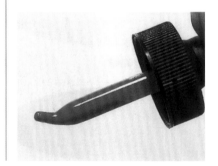

Bottles of liquid acrylics often contain a dropper that is used for transferring the paint onto the palette.

Medium-viscosity acrylic colours

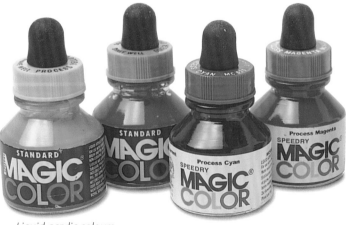

Liquid acrylic colours

Chroma colour

Chroma colour is a type of water-based paint, originally developed for colouring cartoon cells. The colours are vibrant and strong. Made with acrylic resin, the paint can be used in a similar way to watercolour, gouache, ink and, of course, acrylic itself. Chroma colour is fast drying, waterproof when dry and can be massively diluted without losing its strength of colour. It can be mixed with special Chroma mediums to retard drying time and add thickness, gloss or transparency (use of non-Chroma mediums is not advised). It is available in 80 different hues, packaged in 50ml tubes and bottles.

Tubes of Chroma colours

Bottled Chroma colours

Brushes

To a large extent, your choice of brushes will be dictated by the way you work – whether you apply the paint thickly or build up in thin layers. For thick applications and impasto work (see page 90), the bristle brushes made for oil painting are the best choice; while for watercolour styles and thin glazes (see page 86), you would use soft watercolour brushes. However, it is best to use the synthetic version of these, since sables could be spoiled by constant immersion in water.

Probably the best all-round brushes are those that are made specifically for acrylic work, since these combine the characteristics of both oil and watercolour brushes and can be used for medium to thick applications.

Nylon brushes

These brushes are made especially for acrylic work. They come in the standard brush shapes and a wide range of sizes, and are tough, hard-wearing and springy.

1 *Small round nylon*
2 *Small flat nylon*
3 *Medium round nylon*
4 *Medium flat nylon*
5 *Large flat nylon*

Bristle brushes

These, which are usually made from hogs' hair, are the usual choice of artists who like to create oil-painterly effects.

6 *Medium bristle*
7 *Medium-large bristle*
8 *Large bristle*
9 *Small bristle*

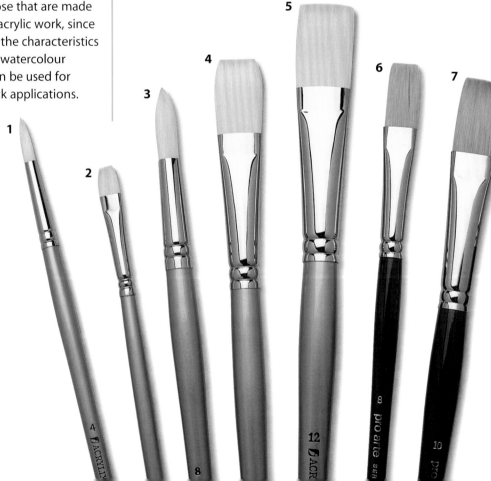

Anatomy of a brush

The size and brand of brush are printed on the handle, and sometimes the style and type of bristle as well. Long-handled brushes are held from the middle towards the end of the handle to create distance and make wider, looser strokes using the entire arm. Short-handled brushes are meant for close-up details and also allow more pressured strokes using the wrist.

Toe: the very top edge of the bristles, the tip.

Bristles (also called the head): the hair filaments, which may be either natural or synthetic or a combination of both.

Belly: the thickest section of the bristles, usually in the middle between toe and ferrule.

Heel: the top section of the ferrule into which the bristles are attached. Its contour defines the shape of the brush.

Ferrule: the part that connects the bristles to the handle. The ferrule is usually metal, but it can be made from wire or plastic.

8

9

Painting knives and paint shapers

Painting knives have a long history, since they have been used by oil painters for centuries, but they are especially well suited to acrylic work because the paint dries fast enough to build up a painting in layers without disturbing the colours beneath. Painting knives are very sensitive implements, made of flexible steel and with cranked handles to hold the hand away from the work. They are made in a wide range of shapes and sizes, with each shape creating a distinctive mark of its own. Some artists use them as an alternative to brushes, while others restrict their use to highlights and accents in the later stages of a painting. Paint shapers look like traditional brushes, with wooden handles and chrome ferrules, but instead of holding bristles, they hold a flexible rubber tip. The tips come in both soft and firm rubber, and are available in a range of shapes and sizes. Pointed, round, chiselled and angled ends move the paint around more in the manner of a palette knife than a brush. They are inexpensive, easy to clean and durable, and although brushes are better for some jobs, shapers make a range of distinctive marks, and are great fun to use.

Painting knives

Palette knife

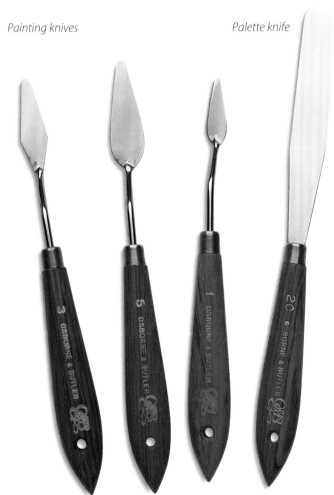

Flat shaper
Interesting patterns can be made using a flat shaper.

Distinctive marks
A shaper can be used to make distinctive marks.

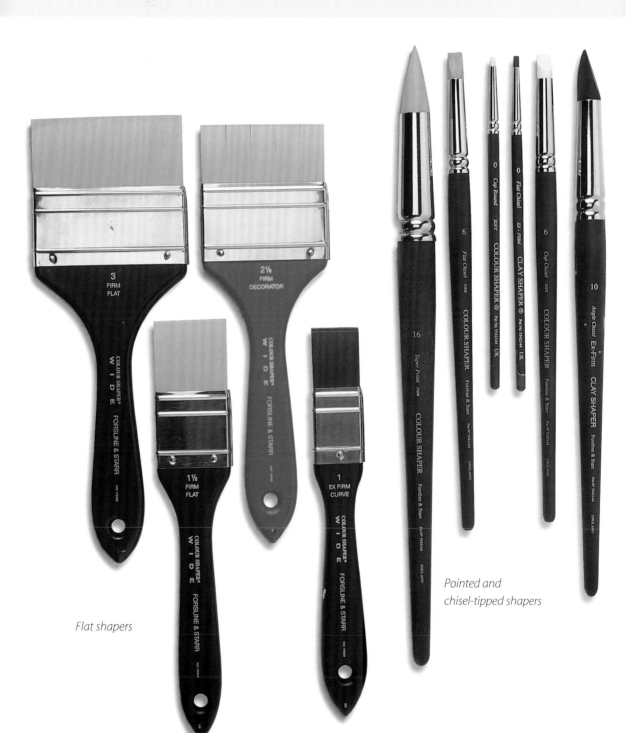

Flat shapers

Pointed and
chisel-tipped shapers

Palettes

Palettes for acrylic work must be made from a non-porous material such as plastic or glass, so don't try using the wooden palettes made for oil painting. Artists who work on a large scale often use sheets of glass, which can be easily cleaned, but if you do this, use heavy glass and tape the edges to prevent cuts. Pieces of laminated board can also be used, but they will become stained.

To prevent the paint from drying out, you can spray with water at regular intervals or use one of the special palettes designed for acrylic work. These are made in two sizes, and are ideal for medium-thick paint applications, where you don't need to lay out large quantities of paint. They also have a compartment for brushes, which you fill with water.

Stay-wet palettes

These have been developed especially for acrylic paint, and can keep the paint wet for several days, or even weeks. They come in the form of a shallow tray with a clear lid, and are sold with a packet of two different types of paper. The absorbent paper is placed in the bottom of the tray and well wetted, and the membrane goes on top. The paint is laid out on the top sheet, and enough water seeps up to keep it moist. You can make your own 'stay-wet' as shown on the next page.

Improvised palettes

Almost anything can be used as a palette – cans, glass jars, pieces of glass, large ceramic tiles, old plates and so on – and the paint can be covered with cling film to keep it moist when not in use.

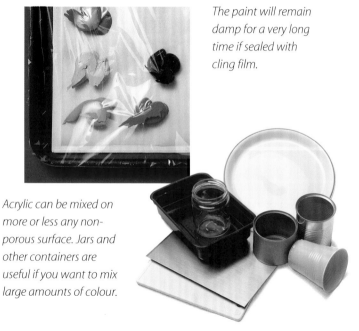

The paint will remain damp for a very long time if sealed with cling film.

Acrylic can be mixed on more or less any non-porous surface. Jars and other containers are useful if you want to mix large amounts of colour.

Making a stay-wet palette

You will need a plastic or metal tray, a piece of capillary matting (as used by gardeners for keeping seed trays moist), same-sized pieces of drawing paper and either thin tracing paper or cooking parchment. You won't be able to make a lid, but you can use cling film instead.

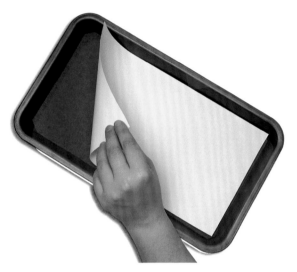

1 Soak the capillary matting and place the drawing paper on top. An alternative is to use blotting paper instead of the matting, in which case you don't need the drawing paper.

2 Carefully place the tracing paper or cooking parchment on top, and you have your palette.

Tear-off palettes

You can buy disposable paper palettes, which you simply throw away after use, or you can use an old telephone directory, removing each sheet when it has become filled with paint.

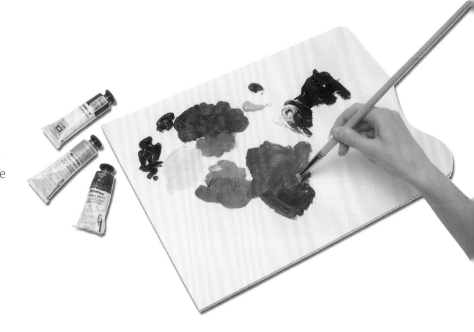

Painting mediums

Although paint can be mixed with water alone, if you want to explore the full possibilities of acrylic you will need to become familiar with the appropriate mediums and find out what they do. The most commonly used mediums are matt and gloss, either of which is mixed with the paint to make it thinner and more transparent (the choice depends on whether or not you want a slight sheen). Gloss medium can also be used as a varnish, and matt medium is a useful primer for canvases (see page 32). Both are sold in bottles.

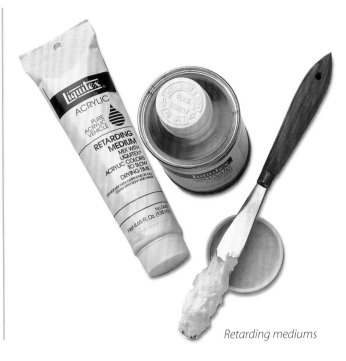

Retarding mediums

Retarding medium

This, which is sold in both tubes and containers, keeps the paint workable for longer, facilitating blending and wet-in-wet techniques. It is best used on its own, since water affects its performance. Take care not to work over a paint and retarder mix when it has become touch dry, because the surface becomes sticky and may be scuffed by subsequent brushwork.

Heavy gel mediums

These mediums are sold in both tube and pot form. They bulk out the paint but also increase its transparency, making it possible achieve exciting surface effects. They are usually mixed with water rather than being used on their own.

Heavy gel mediums

The effects of mediums

Those who have not used acrylics before may be surprised at how much the various painting mediums can alter the look and handling qualities of the paint. They offer exciting possibilities, but don't invest in a whole range until you have established your style and way of working, since they are fairly expensive.

Painting medium

This and the matt version are the standard painting mediums. They are usually mixed with water rather than being used on their own. Both matt and gloss mediums can also be used as varnishes to protect the completed work, but in this case, it is not necessary to add water. Varnishing finished work is not essential, but it can help to revive colours that have become dull.

Modelling pastes

These, sometimes called texture pastes, can be mixed with paint to thicken it, but are primarily intended for creating underlying textures over which thin paint is applied.

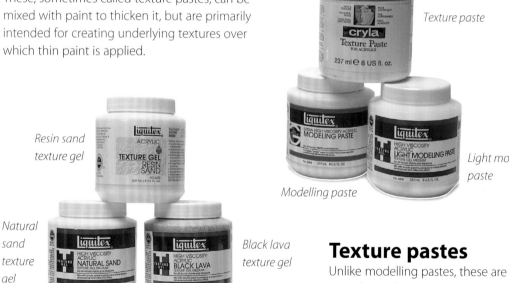

Texture paste

Resin sand texture gel

Modelling paste

Light modelling paste

Natural sand texture gel

Black lava texture gel

Glass bead texture gel

White opaque flakes texture gel

Blended fiber texture gel

Texture pastes

Unlike modelling pastes, these are intended to be mixed with the paint to imitate a range of textures from sand and wood chips to glass beads. A range of different mediums are sold for bulking out paint. Texture pastes are made to resemble natural textures such as sand or fibres.

continued on next page

Retarding medium is a must if you want to work wet-in-wet to achieve oil-paint effects, and for thick paint applications you may want to try one of the heavy gel mediums, which are sold in tubes. These bulk the paint while also making it more transparent, allowing for exciting effects.

Paint straight from the tube (left). Overlaid with iridescent medium (right).

Paint straight from the tube (right). Overlaid with matt medium (left).

Paint straight from the tube (left). Mixed with heavy gel medium (right).

Paint mixed with ceramic stucco, a texture paste.

Several other mediums are sold for impasto work (see page 90), among them being texture pastes and gels, and acrylic modelling paste, which is normally used for underlying textures. There are also 'fun' mediums such as iridescent medium – which produces a range of metallic colours, and a special kind of reflective paint called interference colours – the effect of which is shown on page 24.

Paint mixed with resin sand, a texturing medium.

Paint mixed with blended fibres, a texturing medium.

Paint mixed with ceramic stucco, a texturing medium.

Paint mixed with natural sand, a texturing medium.

Interference colours

You may find it hard to believe, but these two paintings are in fact only one, seen in different lighting conditions. In *View of the Steens*, William E Shumway has stressed the changeable quality of the light by exploiting one of the most intriguing types of acrylic paint: interference colours. These are colourless, transparent paints made from titanium-coated mica flakes, and change their colour according to the angle of viewing. As the light hits the flakes it either bounces off directly, reflecting the labelled colour, or passes through another layer and bounces out at a different refractive index to display the complementary colour. The colours can be applied straight from the tube, thinned with water or mixed with normal colours. Here, the artist has used them both as a transparent medium and for glazing over thick paint.

Rugged effects ▶

The light here has exposed a much more rugged effect, showing up strong darks in the mountains and foreground and an exciting range of blues and yellows in the sky.

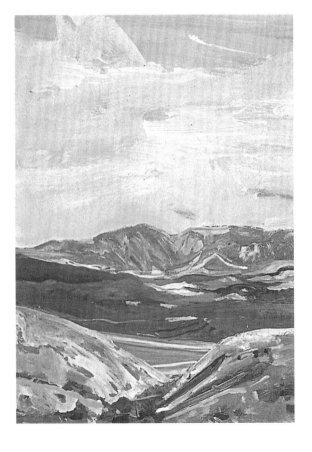

Subtle contrasts

In these lighting conditions, the tone and colour contrasts in the sky are less obvious, but the blue of the hills shows up strongly.

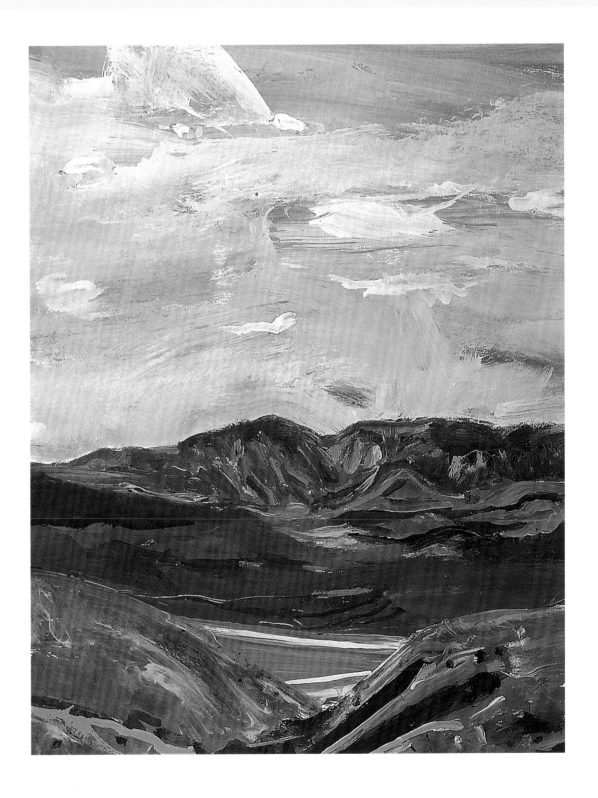

Using thin paint

Acrylic paint can behave in similar ways to watercolour and oil paint, but it is a mistake to think of it as a poor man's version of either. It is an important medium in its own right, and has developed its own range of techniques.

Although flat and graded acrylic washes are made in exactly the same way as watercolour washes, and worked dark over light, they allow for more layers and more variations in the paint consistency than watercolours. Because the paint is stable once dry, there is no danger that overpainted washes will disturb or move previous washes. So, when using transparent methods, don't try to imitate watercolour – this is pointless. Instead, exploit the possibilities of acrylic to create its own unique effects.

Painting in watercolour mode

For this flower painting, the artist is using flow-formula paint (see page 10) with water but no addition of white, and using a soft-haired watercolour brush.

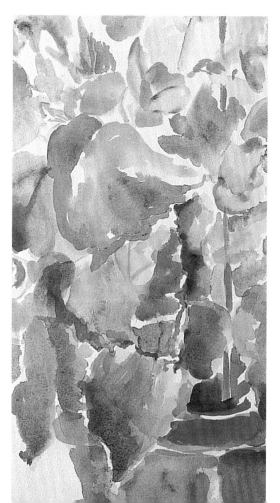

◀ *The completed painting is almost indistinguishable from an actual watercolour. Notice how the highlight whites have been achieved by reserving white paper rather than by using opaque white acrylic.*

Thin wash
Dilution with water or flow medium gives a transparent wash.

Granulation
Some colours granulate when water is applied. This occurs in watercolour also.

Graded wash
Adding water to the mix after each stroke creates a graded wash.

Adding white
The addition of white to the thin paint gives it a gouache-like quality.

Dark over light
The application of dark paint over dry, light paint results in a watercolour-like effect.

Glazing
Acrylic paint is excellent for glazing techniques; its quick-drying capacity enables the completion of a painting in one sitting. Use of transparent colours and a gloss medium will further increase the colours' brilliance and transparency. Complex colour transitions can be built up effectively and easily. (See page 86 for more on this technique.)

Using thick paint

Used straight from the tube, acrylic paint has a buttery consistency. It can be moved and manipulated easily by brush or knife, and its character can be altered by the addition of various acrylic mediums (see page 20). Paint of this consistency is perfect for direct approaches, with even relatively thick paint drying within the hour. Gel medium can be added to preserve brush and textural marks. Blending, scumbling and broken-colour techniques all work well with paint of this consistency. For impasto work, use tube acrylic paint extended with a heavy gel medium, or with a texture medium or paste. Alternatively, you can create your own texture medium using additives like clean sand or sawdust (see pages 20 and 118).

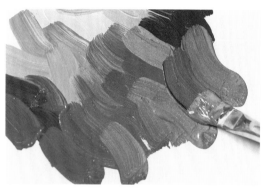

Direct painting

Acrylic paint of a buttery consistency is perfect for more rapid applications.

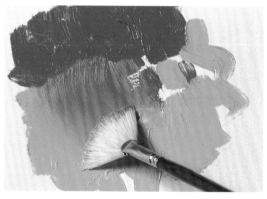

Blending

Acrylic paint must be blended quite quickly, before it begins to dry.

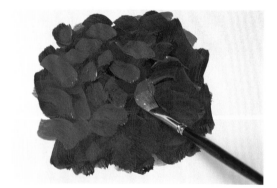

Broken colour

Areas of broken colour can be built up relatively easily, because the paint dries quickly.

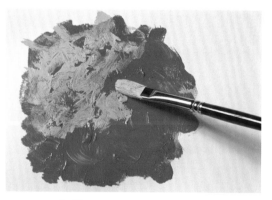

Scumbling

In this technique, a layer of wet paint is brushed over an initial dry, textured layer.

Texture mediums

Prepared texture mediums can be added to the paint to imitate a wide range of natural textures.

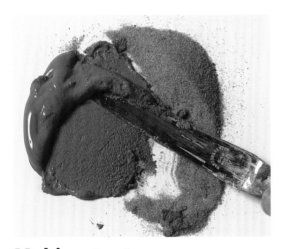

Making texture

Add fine sand to the paint for a textured look, but make sure the sand is clean.

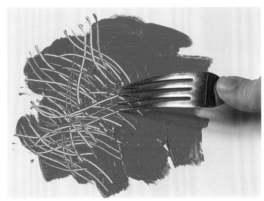

Fork

Any household implement can be used to make impressions in impasto paint.

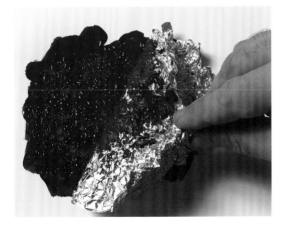

Tin foil

Crumpled tin foil pressed onto paint will give a stucco effect to your work.

Comparing methods

These two paintings show two very different uses of acrylic paint, one resembling an oil painting and the other looking more like a watercolour or gouache painting.

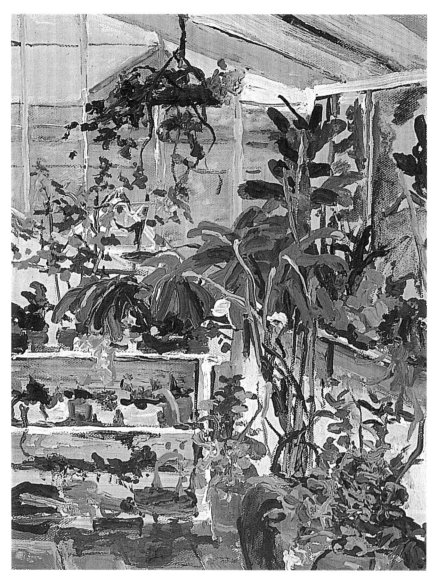

Oil-paint effects

Don Austen's *Barbara Hepworth's Greenhouse with Hanging Basket* was painted on canvas, with the paint built up thickly with energetic and varied brushmarks. In places, the paintwork looks a little like knife painting (see page 98) but, in fact, bristle brushes were used throughout.

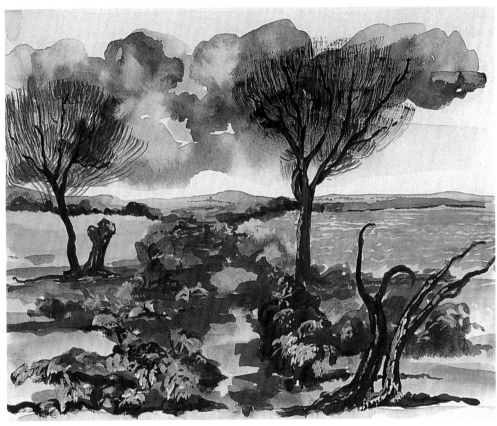

Gouache effects

For this cool winter landscape painted on the spot on a small piece of card, Roy Sparkes began with paint diluted to a watercolour consistency, letting the colours merge wet-in-wet (see page 92) in the sky area and gradually thickening the paint towards the foreground.

◀ *In this detail, you can see the contrast of thin and thick paint. The area at top right has been built up with overlays of transparent colour, as has the path on the left, but relatively thick paint of a gouache-like consistency has been used to suggest the highlights on the foliage.*

Home-made canvas boards

Suitable thin fabrics like canvas, hessian, muslin and calico can be glued to a board such as masonite to give it a textured surface. This method, called marouflaging, is an extremely inexpensive and effective way of using up fabric and offcuts from boards, and results in a support that is excellent for use on location.

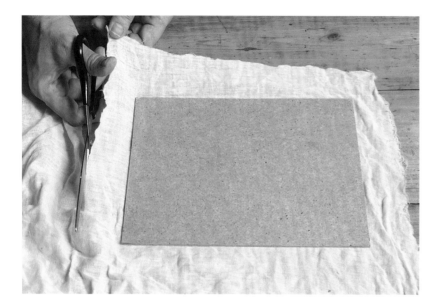

1 Rub the board thoroughly with a damp cloth to remove any dust, then place it face down onto the fabric. Cut the fabric to size, leaving a 50 mm (2 in) overlap on all four edges.

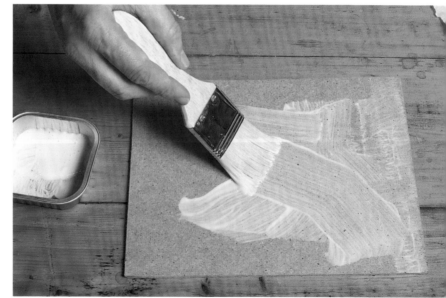

2 Turn the board face up and liberally paint the surface with a coat of acrylic matt medium.

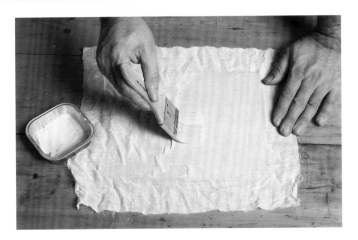

3 Place the fabric square onto the board and brush on more medium. Start from the middle and work out to the edges, applying enough pressure to make sure no air bubbles or thick pockets of glue or medium are left. Continue until the fabric is completely flat.

4 When dry, turn the board over and place it on a block of wood. Apply acrylic matt medium around all four edges.

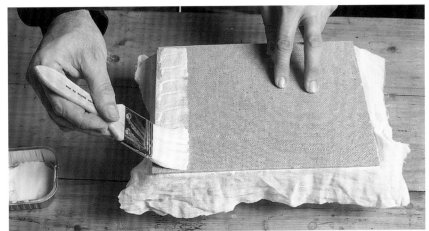

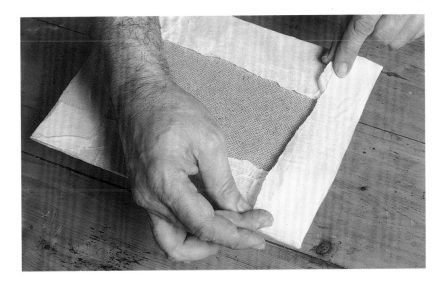

5 Fold the fabric over the sides and onto the back of the board. Smooth down using more acrylic matt medium. If the medium has raised the grain of the fabric, rub down lightly with glasspaper.

Stretching canvas

Stretching your own canvas is not only economical – it also allows you to prepare the canvas in accordance with your own specifications. Canvas is stretched over a frame made from mitred wooden stretcher bars, available from art stores in a range of lengths, widths and profiles – only stretcher bars of the same width and profile will fit together. Stretcher pieces are usually classified as economical, mid-quality or professional quality, and are made from various species of kiln-dried pine or tulip wood. The highest-quality stretchers are jointed using a dovetail joint; others use a mortise and tenon. Many stretchers incorporate two slots into the corner joint to allow a triangular wooden wedge to be inserted; this can be used after priming to push the wood apart and apply lateral pressure to the canvas, stretching it taut.

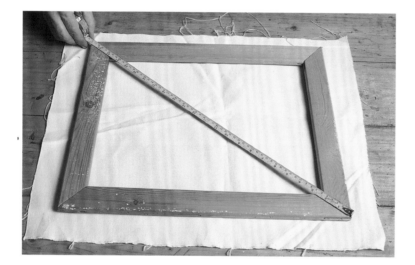

1 Cut the canvas so that it is about 50 mm (2 in) larger than the stretcher frame. Assemble the stretcher, and check that it is square by measuring diagonally from corner to corner: if the measurements are the same, the frame is square.

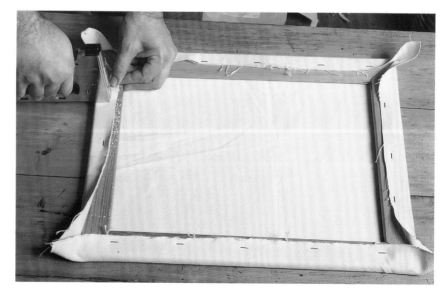

2 Pull the canvas overlap up the sides and over onto the back of the stretcher frame. Secure at even 50 mm (2 in) intervals with staples.

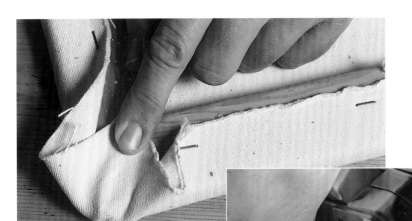

3 Working one corner at a time, pull the corner of the canvas tightly across the back of the stretcher towards the centre. Fold one of the canvas wings in and over.

4 Secure the fold to the stretcher frame using a single staple.

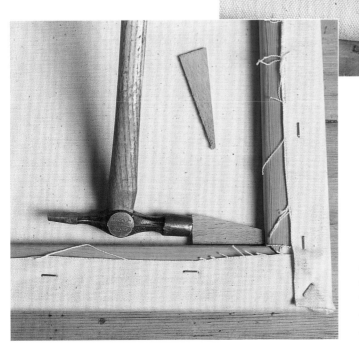

5 If the canvas remains limp when dry, it can be made taut by forcing the stretcher bars apart using wooden wedges hammered into the slots at each corner.

Priming and staining

Gesso gives an inflexible, slightly absorbent surface. Traditional gesso is made by mixing whiting with warm glue size and white pigment. (Black gesso is also available; another alternative is to tint acrylic gesso with black acrylic paint.) Acrylic gesso has one clear advantage over traditional gesso: it is flexible, and so it can be used on stretched canvas. Smooth boards are usually given several thin coats of gesso, with each coat painted at a right angle to the previous coat. Each coat is allowed to dry, and then sanded using fine-grit sandpaper before the next coat is applied. The number of coats required depends on the degree of surface smoothness desired.

1 Using a soft bristle brush, apply a layer of gesso to the surface of the board.

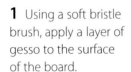

2 When the gesso is dry, sand the surface to remove any brushmarks.

3 Repeat steps 1–2 using brushstrokes painted at right angles to the previous ones. Always sand between coats.

Staining

Acrylic paint contains no corrosive ingredients that might degrade paper or fabric, making it possible to work directly onto canvas, without any prior sizing or priming. Acrylic paint applied to unsized canvas will soak into it, staining the fabric fibres; this stained layer can be sized and then worked on in a conventional manner, or worked on without sizing. Always work dark over light, allowing each stain to dry before applying the next. Too many stained paint layers will dull the colours. Raw canvas repels paint, while a flow medium added to a thin-colour mix improves absorption. The support should be placed flat, or the thin paint will run. Once the paint has soaked into the fibres, it is impossible to remove, even when wet.

Flow medium has been added to the paint, helping the canvas to absorb the colour.

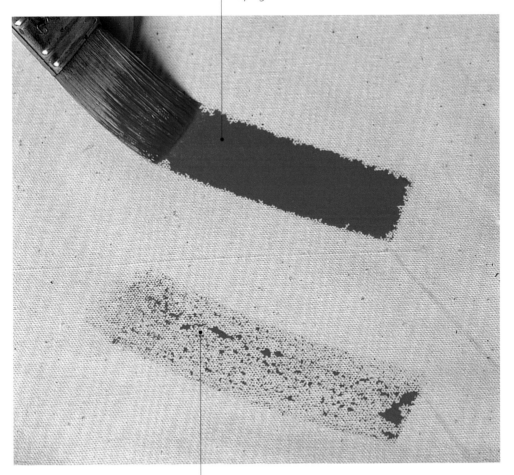

Priming and staining
Here you see how the unprimed canvas rejects the paint, sitting on top of it rather than sinking in.

Stretching paper

When wetted, paper fibres absorb moisture like a sponge and swell, causing the paper to buckle. When the fibres dry, they shrink again – but not always to the original size – and the buckling can persist. The application of watery acrylic over such an uneven, 'wavy' surface can be difficult. Stretching the paper helps to solve this problem by ensuring that the sheet dries flat each time it is wetted. You will need a sheet of paper, a wooden board that is larger than the paper, adhesive paper tape, a sponge, a craft knife and clean water.

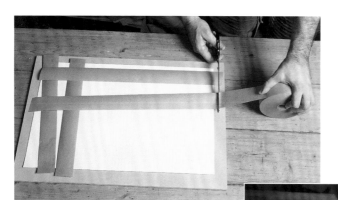

1 Prepare four strips of adhesive-paper tape, cutting each strip approximately 50 mm (2 in) larger than the paper.

2 Lay the sheet of paper centrally on the wooden board and wet it thoroughly, squeezing water from the sponge. Alternatively, the paper can be wetted by holding it under a running tap, or by dipping it into a water-filled tray or sink.

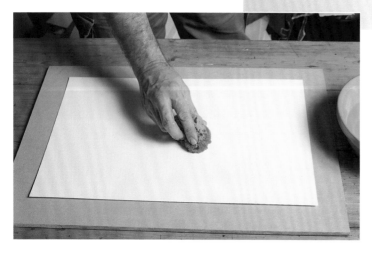

3 Wipe away any excess water with the sponge, taking care not to distress the paper surface.

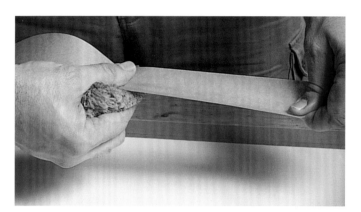

4 Beginning on the longest side of the paper, wet a length of tape using the sponge, and lay it down along one edge. Ensure that about one-third of the tape surface is covering the paper, with the rest on the board.

5 Smooth the tape down with the sponge. Apply the tape in the same way along the opposite edge and then along the other two edges. Place the board and paper aside to dry for a few hours; or use a hairdryer to speed up the drying process, but keep the dryer moving so that the paper dries evenly, and do not hold it too close to the paper's surface.

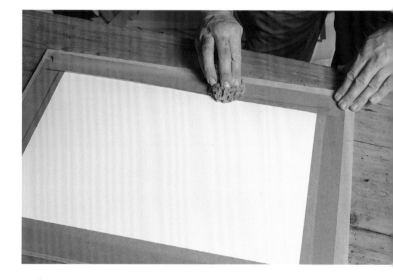

ARTIST'S TIP

Staples can be used to secure medium- and heavyweight papers. Wet the paper and position it on the board, as above. Secure the edges by placing staples about 13 mm (½ in) in from each edge, and at 13–25 mm (½–1 in) intervals. Work quickly, before the paper buckles. Allow to dry as above.

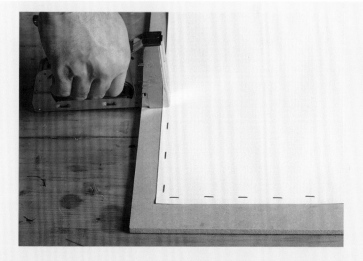

2
Colour

Primary colours

The three primary colours, so called because they cannot be mixed from other colours, are red, yellow and blue. A mixture of two primaries produces a secondary colour: red and blue make purple; blue and yellow make green; yellow and red make orange. But there are many different reds, yellows and blues, and the secondary colour obtained will depend on which ones are used. The tertiary colours are mixtures of three colours, that is, one primary and one secondary.

Creating secondaries

Pure secondaries are obtained by mixing primaries that show a bias towards one another on the colour wheel. Subdued secondaries are created by mixing primaries that are further apart on the colour wheel.

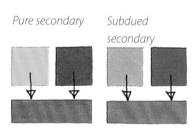

Pure secondary Subdued secondary

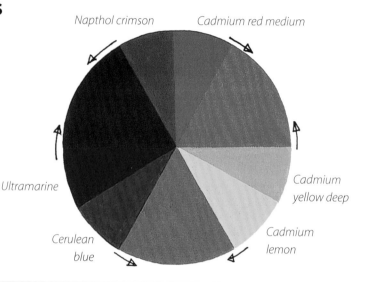

Napthol crimson Cadmium red medium

Ultramarine

Cadmium yellow deep

Cerulean blue

Cadmium lemon

Mixing tertiaries

The tertiary colours are those that fall between the primaries and the secondaries. They are made by mixing equal amounts of a primary and the secondary next to it. The colours are red-orange, yellow-orange, yellow-green, blue-green, blue-violet and red-violet.

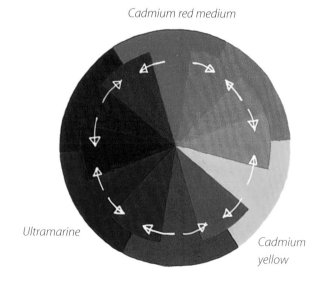

Cadmium red medium

Ultramarine

Cadmium yellow

Primary choices

In theory, you can mix all colours from only three – red, yellow and blue – but in practice it is not quite that simple, because there are different versions of these colours. In a limited palette, select two types of each, for example, cadmium red and crimson; cadmium yellow and lemon yellow, ultramarine and phthalo blue. Used in pairs, these give you many grades of secondary mixes – oranges, purples and greens – and by mixing two or more colours, you can obtain subtler shades and neutral colours. This chart shows a selection of these two-colour mixes.

Basic colour wheel *This six-colour wheel shows the three primary colours and the secondaries made by mixing each of the primaries on either side. Simple wheels like this serve a valuable information purpose, but are of limited use when learning to mix colours, since they show only one version of each primary. However, you can see the position of the complementary colours, which play an important role in painting – these are explained on the following pages.*

Pigment colour wheel *This wheel has been painted with acrylics, and shows two versions of each of the primary colours. Notice that they do not all correspond with the pure primary values of the printed wheel, since pigment colours are much more varied than those used for printing, and the colour-mixing methods are different. The secondaries here show only one of many possibilities; you can make a much wider selection by varying the proportions of the primaries and by adding white, of course.*

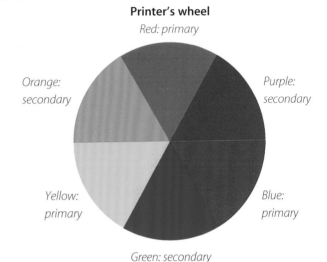

Printer's wheel

Red: primary

Orange: secondary

Purple: secondary

Yellow: primary

Blue: primary

Green: secondary

Pigment wheel

Cadmium red medium

Permanent alizarin crimson

Mixture

Mixture

Cadmium yellow deep

Ultramarine blue

Cerulean blue

Cadmium lemon

Phthalo blue green shade

Mixture

Complementary colours

Complementary colours are those that are opposite each other on the colour wheel: orange and blue; red and green; violet and yellow. Good use can be made of these in painting. When juxtaposed, complementary colours create vibrant contrasts, while a colour that looks too loud or bright can be 'knocked back', or neutralized, by mixing in a little of its complementary. Another point to remember is that mixtures of complementary colours will produce neutral colours, so you can 'knock back' a green that is too harsh by adding a little red, or vice versa.

Juxtaposing complementaries
Dynamic contrasts are created by putting complementary colours next to each other.

Orange

Blue

Red

Green

Violet

Yellow

Neutralizing colours *By mixing in a little of a colour's complementary, brash colours can be 'knocked back' and made more subtle.*

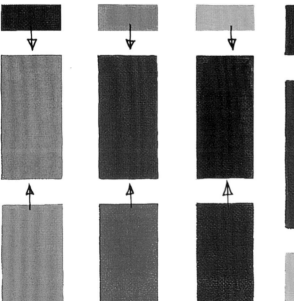

Mixing neutrals *A whole range of greys and browns can be created by using mixtures of complementary colours.*

Optical mixing

The French painter Georges Seurat and others used to put small dabs or strokes of contrasting colours next to each other on the canvas, so that from a distance they would 'mix' in the eye of the viewer. This method, called pointillism, creates a lively impression, best appreciated at a distance so that 'optical mixing' can take place. Versions of the technique are still used today. For the best results, the colours might be close in tone (i.e. of a similar lightness or darkness). Here are some examples:

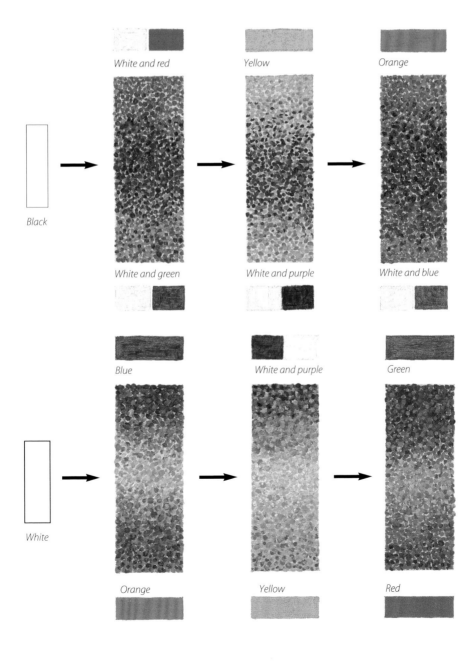

Using complementary colours

Paul Powis has used the mauve/yellow complementary contrast very effectively in his painting, also bringing in subtle touches of the red/green contrast. His approach and method of execution are both very interesting. After working out a series of small sketches, he begins the painting proper on plywood that has been given a gloss black ground. Onto this, the shapes and elements are drawn in bright pastel before the paint is added.

▼ Using large brushes, the artist paints the complementary of the colour he wants to end up with. In this case he wants a purple, and so the underpainting is done in yellow-orange.

◄ Working initially into the black ground, the colours are mixed very carefully until the tonal values are correct.

▲ The paint is worked wet-in-wet, using very direct and immediate brushstrokes.

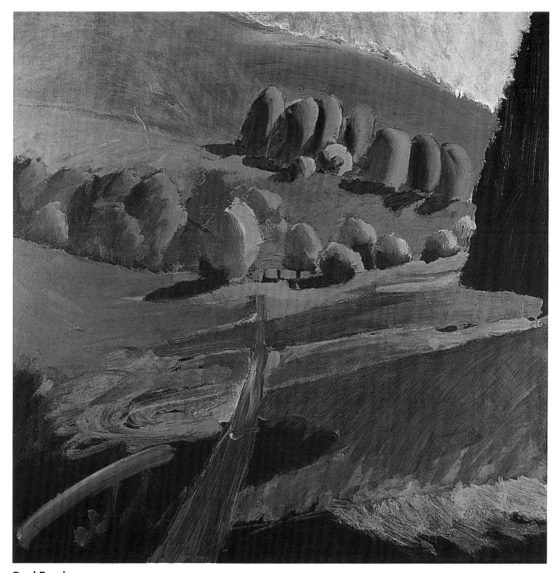

Paul Powis
The Malverns
In addition to using heightened, non-naturalistic colour, the artist has also combined semi-abstract shapes with realistic ones. The trees, although simplified, are clearly recognizable. However, the shapes in the foreground that lead the eye towards the focal point are not treated descriptively, because all that matters is the role they play in the composition.

A basic palette

When you are new to painting, it can be difficult to decide which colours to buy, since there are so many choices available. One way around this problem is to purchase one of the manufacturer's set of colours and add to them as and when you discover limitations. It is better – and more enjoyable – to select your own tubes. As long as you remember that you will need two of each of the primary colours (see page 42) you won't go far wrong. The suggested palette shown here adds a few extra colours to make 14 in total, including white. Those marked * are not strictly essential.

Titanium white *Strong and opaque. This is the only white available in acrylic ranges.*

Cadmium yellow deep *A strong, warm yellow tending towards orange, with good tinting strength.*

Cadmium red medium *Warm orangey-red, strong and opaque and with good tinting power.*

Yellow ochre * *Not strictly essential, since a similar colour can be mixed, but worth including because it is often used.*

Alizarin crimson *A cool, slightly transparent red, good for glazes and in mixtures.*

Ultramarine *The best all-round blue, strong and warm. Tends to become dulled when mixed with white, but mixes well with other colours.*

Cadmium yellow lemon *A strong, acid yellow that mixes well with cool blues. Known by different names, but the word lemon always features.*

Phthalo blue *A very strong, greenish blue. Use with caution in mixtures, as it can overpower other colours. Also known as Winsor blue and phthalocyanine blue.*

Dioxazine purple * *A strong purple. Not strictly essential but is valued for its use in mixes.*

Raw umber *A dark greenish brown that leans towards grey when mixed with white. Useful all-round colour.*

Phthalo green *Strong bluish green that makes a good base for mixing a range of cool greens. Viridian is an alternative, but is not as strong.*

Burnt sienna * *A strong red-brown that gives a surprising range of colours when mixed.*

Chromium oxide green * *An opaque, dull green that mixes well with other colours without overpowering them.*

Payne's grey * *Mixes well with other colours to produce dark tones without deadening them, and can also be used on its own. Some artists prefer black.*

Paint charts

All paint manufacturers produce colour charts to help you make choices. These can be very useful, but bear in mind that printed and pigment colours always vary slightly.

Lightening and darkening colours

The obvious way to make colours lighter or darker is to add white and black (or grey) respectively, but this doesn't always work because it can change their hue. Black mixed with yellow, for example, makes green (worth remembering since this is a useful mixture), while white added to cadmium red results in a cool pink. Sometimes a better way of making a colour lighter or darker is to add another one. For example, lemon yellow, which is pale in tone, can lighten one of the naturally dark reds, and yellow itself can be darkened by adding one of the browns. The chart opposite will give you some more ideas.

Overlaying colours

Colours can be lightened or darkened on the picture surface as well as by mixing in the palette. This can often create more exciting effects. The three examples below show darkening colours.

Dioxazine purple over alizarin crimson

Burnt sienna over lemon yellow

Burnt umber over cadmium red

Lightening by overlaying

These three examples show some alternatives for lightening colours. You can also, of course, use overlays of semi-transparent white.

Cerulean blue over ultramarine

Lemon yellow over burnt sienna

Yellow ochre over raw umber

Plus white	**Plus black**	**Lightening colours**	**Darkening colours**

Cadmium yellow

Plus lemon yellow

Plus raw sienna

Cadmium orange

Plus lemon yellow

Plus alizarin crimson

Alizarin crimson

Plus cadmium red

Plus cobalt blue

Windsor violet

Plus permanent rose

Plus ultramarine

Cobalt blue

Plus cerulean blue

Plus ultramarine

Cadmium green

Plus lemon yellow

Plus chromium oxide green

Laying out and mixing colours

Whether you use a large palette of colours or a small selection as shown here, always lay them out in some kind of logical order so that you can find them easily. One blob of dark colour looks very much like another one, and it is very frustrating to find you have accidentally added green or brown to a blue sky mix. These colours are laid out from light to dark, with the colour 'families' – reds, blue and so on – grouped together. White can be placed at either end, but remember to lay out a larger quantity because you will use more of this than the other colours (unless you are working in 'watercolour mode').

Practicalities *This palette has been prepared for illustration purposes only. In reality, only lay out small quantities of acrylic colour at a time, since they dry so rapidly. If you don't need a certain colour, leave a space and add it later.*

Alizarin crimson

Cadmium red

Cadmium yellow

Phthalo blue

Ultramarine

Lemon yellow

Dioxazine purple

Raw umber

Payne's grey

Titanium white

Mixing on the palette

If you are using a stay-wet palette (see page 18) you will have to mix with a brush, otherwise you could damage the paper membrane. For large quantities of paint mixed on a rigid palette, such as a sheet of glass, it may be easier to work the colours together with a palette knife. Knife mixing is especially useful if you are mixing your colours with a bulking medium for impasto work, since brushes will quickly fill up with paint and be difficult to clean.

Order of mixing *When mixing a pale colour, start with the weakest ingredient, say yellow or white. Then add the stronger colours in small quantities, building up gradually to the strength you require. If you begin with a very strong hue you will have to add much more of the mixer colours, wasting a lot of paint.*

Knife mixing *Unless you want a streaky effect, which can be useful in certain cases, blend the colours together thoroughly. Don't just mash them together, since this can leave them partially unmixed; use the knife to scoop up the paint and knead the colours into one another.*

Brush mixing *This photograph shows what happens when thick paint is mixed with a brush. If a brush becomes overloaded with paint, act fast before it begins to dry. Lay the brush flat on the palette and run the edge of a palette knife or plastic card down the bristles from base to tip, then immerse the brush in water.*

Learning colours

Mixing colours is something that comes with practice, but the first skill that must be mastered is that of identifying the colours you see and thinking of them in terms of the paints on your palette. Anyone can describe a colour in its most basic terms – even small children can see that something is red, yellow or blue – but deciding what kind of colour it is is more difficult, especially in the case of neutral colours, which often don't seem to fit into any clear category. But even neutrals have some kind of colour bias: grey can be blue-grey or green-grey, while browns range from near-reds to greenish yellows.

So when you look at something, try to think your way through the following checklist of points, which will give you a clue as to the ingredients of your mix.
• What kind of colour is it?
• Is it light, mid-toned or dark?
• Which of my tube colours is nearest to it?
• Does it have a distinct tinge of another colour?
• Is it warm or cool?
• Is it intense or subdued?

The colour swatches below show examples of how these principles can be applied.

Modifying colours

One of the things that often goes wrong with colour mixing is that the colour looks right on the palette and wrong when you paint it on. This is because colours don't exist in isolation; their individual identity derives from their relationship with other colours. A neutral colour that looks relatively dull on the palette can appear quite vivid and glaring if it is painted in among other even more subdued colours, and its colour bias will become much more obvious. Similarly, a bright colour may become dulled unless it is contrasted with neutrals or with darker or lighter tones. Colour is full of surprises, sometimes unhappy ones, but in acrylic it is very easy to modify colours, either by overpainting or by glazing (see page 86).

Warm	Cool	Dark	Light	Colour bias

Cadmium red + black + white	*Phthalo green + black + white*	*Dioxazine purple + phthalo green*	*White + lemon yellow + black*	*Lemon yellow (+ raw umber + white)*

Cadmium yellow + white + dioxazine purple	*Dioxazine purple + raw umber + white*	*Ultramarine + napthol crimson*	*White + dioxazine purple + cadmium yellow*	*Ultramarine (+ raw umber + white)*

Modifying hues

Some acrylic colours are very strong and artificial-looking and are not always suitable for painting natural subjects. If you want to modify a hue quite subtly, try adding small touches of subdued earth colours – the muted browns and yellows. For example, mix burnt sienna into green, and yellow ochre into mauve.

Bright green

Bright green with burnt sienna added

Bright green mixed with red-violet

MIXING COLOURFUL NEUTRALS

Neutral colours need not be dull, and it is worth experimenting with different ways of mixing them. One easy and quick method is to mix complementary, or opposite, colours such as red and green (see page 44). The kind of mixture you achieve depends on the proportions of the mix. The same method can be used to modify colours, either by glazing or by adding a little of the opposite colour to the palette mixture.

Knocking back colours

If one colour in your painting looks too bright, lay a thin, neutral-coloured glaze over it, using a large, soft brush and paint mixed with either water alone or a mixture of water and acrylic medium (see page 20). Colours that are either too light or too dark in tone can be modified in the same way with darker or lighter versions of the original colour, or with very thin white or grey.

 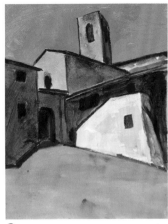

1 *A vivid purple, diluted with water, is laid over dry paint.*

2 *The effect was found to be over-bright, so it is modified with glazes of a more subdued hue.*

3 *The finished effect is still bright due to the strong contrasts, but the purple is slightly more subtle.*

Mixing by glazing

A glaze is a transparent layer of paint applied over another colour so that it tints and modifies the underlayer. Any number of glazes can be superimposed as long as each is allowed to dry before painting the next. Glazing was originally an oil-painting technique, but is ideal for fast-drying acrylics, and the effects are quite unlike those simply achieved with opaque mixtures.

Mixing and glazing – comparing the effects

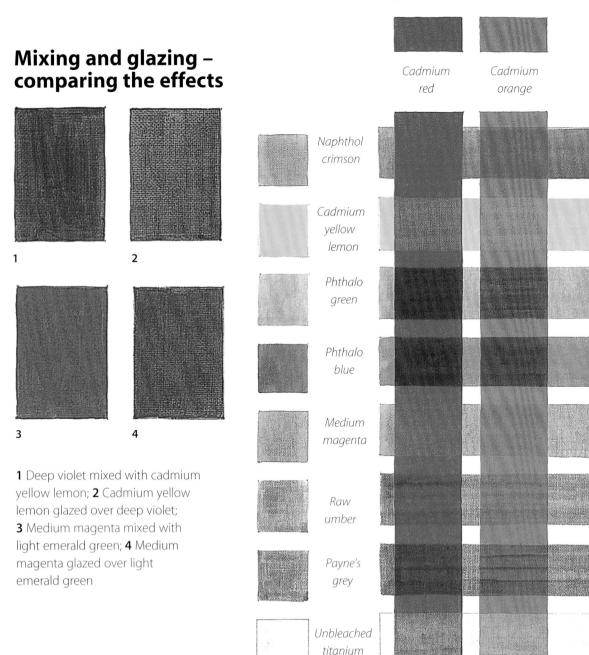

Cadmium red

Cadmium orange

Naphthol crimson

Cadmium yellow lemon

Phthalo green

Phthalo blue

Medium magenta

Raw umber

Payne's grey

Unbleached titanium

1
2
3
4

1 Deep violet mixed with cadmium yellow lemon; **2** Cadmium yellow lemon glazed over deep violet; **3** Medium magenta mixed with light emerald green; **4** Medium magenta glazed over light emerald green

▼ The horizontal bands of colour have been laid over the vertical ones. Notice that the degree to which the colours are amended depends on the tone and relative opacity of the pigment.

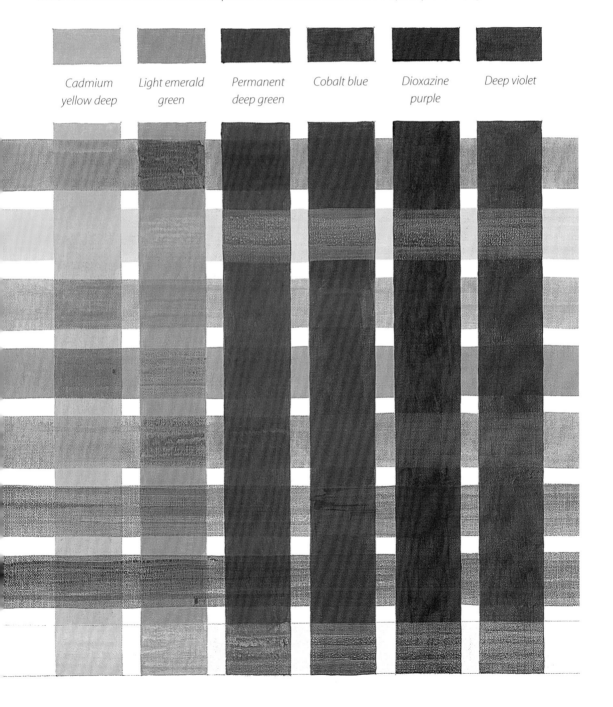

Cadmium
yellow deep

Light emerald
green

Permanent
deep green

Cobalt blue

Dioxazine
purple

Deep violet

Using glazes

This painting, done on smoothly primed board, shows the depth and intensity of colour that can be achieved by glazing. A detailed pencil drawing was made before washing over the board with a yellow oxide and white mix. The landscape was developed with orange and purple washes, allowing each previous layer to show through. The figure of the girl was worked in much the same way, but with more layers of thicker paint to give her an impression of solidity.

▲ *The texture of rock and sand was achieved by loosely scrubbing on the paint with a bristle brush. This causes the paint to froth. When dry, the shapes of the bubbles are visible, with subsequent layers exaggerating the effect. A cadmium yellow and naphthol crimson mix make up the base colour for the rocks, with naphthol crimson and cobalt blue added by degrees for the areas in shadow.*

▲ *The purple of the pyramids consists of Payne's grey, naphthol crimson and titanium white. Although the colour scheme is essentially warm, the coolness here helps to suggest distance.*

▲ *The darker hair was painted first with a mix of yellow ochre, Payne's grey and titanium white. When dry, masking tape was put onto the hair area and the light wisps of hair cut out; these were then painted with a thick mixture of cadmium yellow and titanium white.*

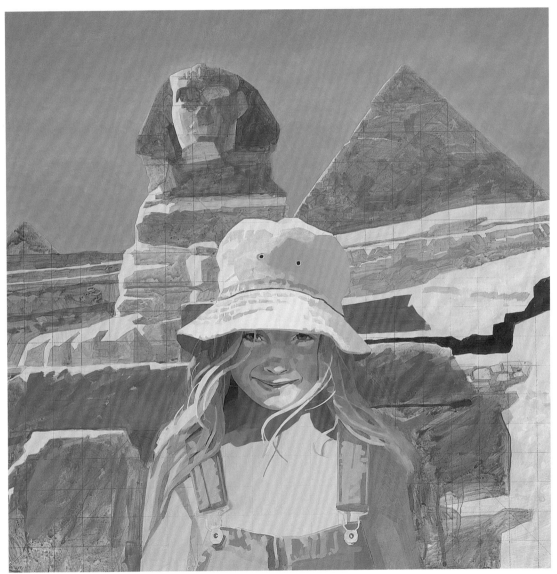

Ian Sidaway
The Sphinx, the Pyramids and Alice at Giza

◀ *The skin tones were obtained by using the same combination of colours used on the rocks with the addition of yellow oxide and white for the highlights.*

Using a limited palette

The chart below shows how a large range of colours can be achieved with only eight basic hues. The horizontal band of swatches has been mixed with the vertical band in a ratio of 20:80, and changing the ratio will give an even wider selection.

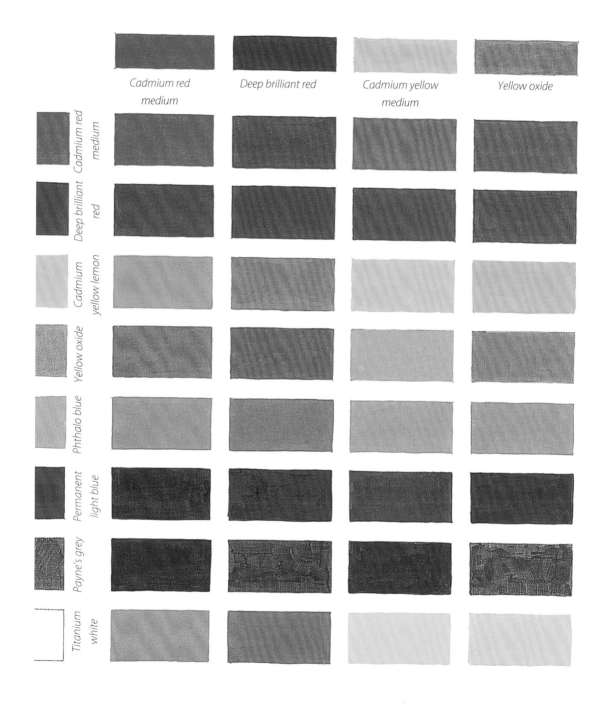

	Cadmium red medium	Deep brilliant red	Cadmium yellow medium	Yellow oxide
Cadmium red medium				
Deep brilliant red				
Cadmium yellow lemon				
Yellow oxide				
Phthalo blue				
Permanent light blue				
Payne's grey				
Titanium white				

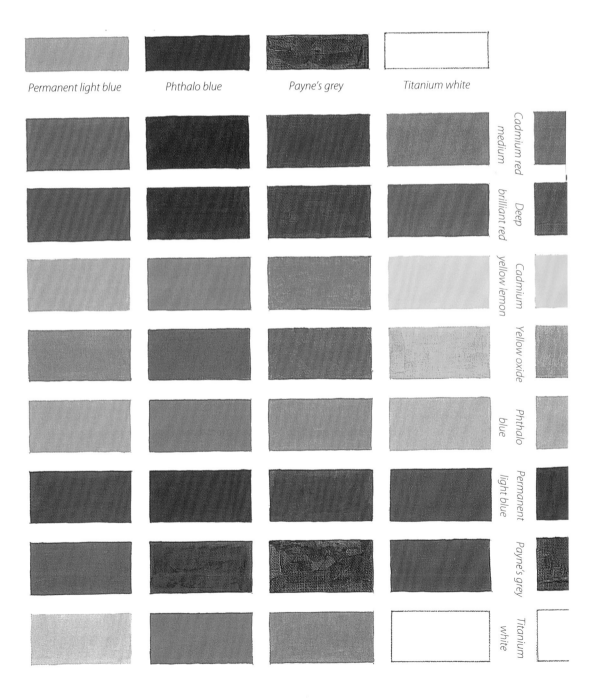

Permanent light blue Phthalo blue Payne's grey Titanium white

Cadmium red medium

Deep brilliant red

Cadmium yellow lemon

Yellow oxide

Phthalo blue

Permanent light blue

Payne's grey

Titanium white

Mixing greens

Greens vary hugely in nature, but many beginners fail to mix a satisfactorily wide range. This chart should provide some ideas. Each group of three swatches shows: top = 50:50 pure mix, centre = white added to top swatch, bottom = white added to centre swatch.

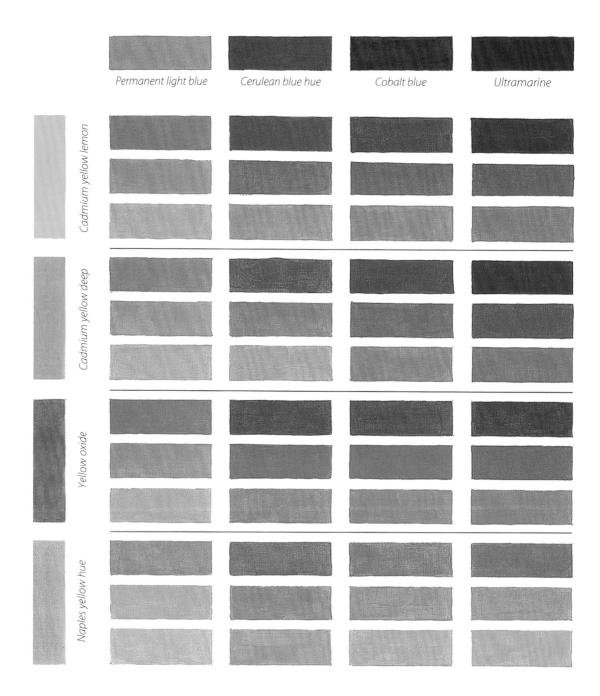

Permanent light blue *Cerulean blue hue* *Cobalt blue* *Ultramarine*

Cadmium yellow lemon

Cadmium yellow deep

Yellow oxide

Naples yellow hue

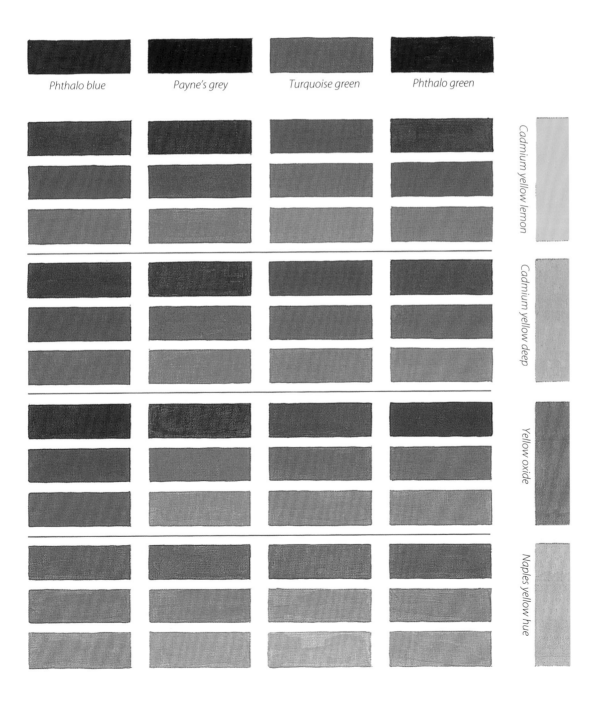

Phthalo blue

Payne's grey

Turquoise green

Phthalo green

Cadmium yellow lemon

Cadmium yellow deep

Yellow oxide

Naples yellow hue

Mixing browns and greys

This chart shows that many of the so-called neutral hues are actually quite colourful. Each group shows: top = 50:50 pure mix, centre = top swatch with white added, bottom = centre swatch with white added.

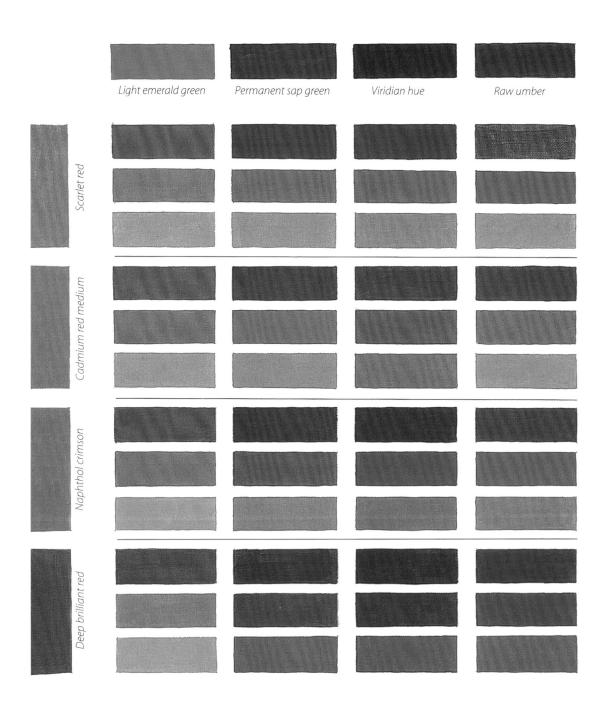

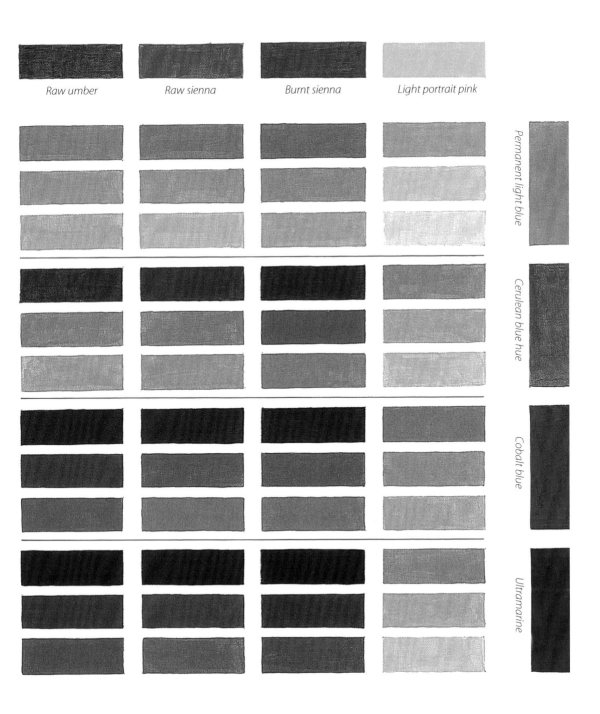

Raw umber

Raw sienna

Burnt sienna

Light portrait pink

Permanent light blue

Cerulean blue hue

Cobalt blue

Ultramarine

Personal approaches

Learning to mix colours is a basic skill like any other, but using colour is a vital part of the artistic process, and your choice of colours gives you a means of self-expression. Many artists' work is immediately recognizable by the personal palette they use, which tends to be similar whatever their subject matter.

Peter Burman
River Deben, Suffolk
In dramatic contrast to Gerry Baptist, this artist has muted his colours where necessary and brought in blue-greys to contrast with the pale yellows of the sunlit fields. This painting is about light. Notice that only the most subtle and dulled-down greens have been used for the trees, since any vivid greens would have stood out too much and detracted from the drama of the stormy sky.

◀ **Gerry Baptist**
Pines in a Clandon Garden
This artist enjoys using heightened colour whether he is painting landscape, still life or portraits, and his painting has a jewel-like quality reminiscent of the paintings of Matisse and the fauve painters. Although the colours are not realistic, there is nothing arbitrary about their use, and each one is carefully mixed on the palette before applying. The only neutral colour used in this painting is the blue-grey of the sky, which helps the brilliant reds and blue-greens to sing out.

3
Techniques

Underdrawing

It is not essential to draw before you paint, but it is wise to do so if your subject is at all complicated or involves hard-to-draw elements, such as figures. If you are using opaque techniques, the paint will completely cover your drawing, so you can draw in whatever medium you like – pencil, charcoal or a brush and thinned paint – though charcoal is best avoided if you intend to start with pale colours, since it can muddy them slightly.

Transparent techniques need more planning, since heavy lines may show through the washes, particularly in very light areas. So keep the lines as light as possible, avoiding shading, and don't start to paint until you are sure the drawing is correct.

1 A light pencil drawing like this is best for transparent watercolour-style applications.

2 If a stronger drawing is needed, light washes can be laid over the pencil drawing in the areas that are to be darker in the painting.

3 For more opaque techniques and bolder treatments, a brush drawing is the most common method. If any lines threaten to show through, they can be overpainted in white.

Building up

The way you proceed with a painting in acrylics depends to a large extent on your individual working method and on how you are using the paint – thick, thin or medium. If you are exploiting transparent techniques on paper, you will want to begin with light washes of colour, building from light to dark in the traditional watercolour manner.

For opaque treatments, it doesn't matter where you begin or which colours you put down first, because you can overpaint as much as you like without harming the colours beneath.

A good general rule is to block in the most important areas of tone and colour first and then work all over the picture at the same time, always bearing in mind the relationships between the various shapes, tones and colours. The following pages show three different approaches.

Medium consistency paint on paper

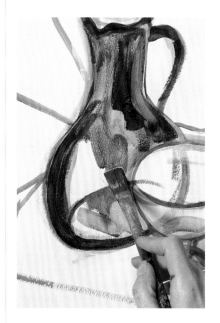

1 Working on watercolour paper with a medium (slightly textured) surface, this artist first made an outline brush drawing and now lays in colour, using water-thinned paint for the carafe to simulate the transparency of the glass. Although the glass has a greenish tinge, it reflects the colour of the background, so a warm brown is chosen.

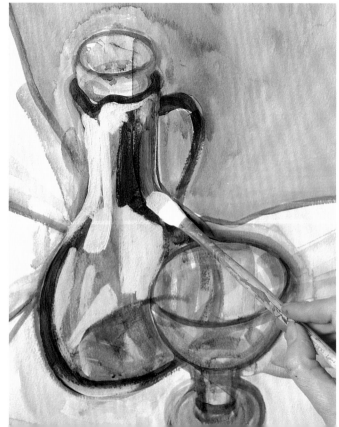

2 The subtle colours of the glass have been built up with a series of transparent washes, while thicker paint, applied with a bristle brush, has been used for the highlights on the carafe. The same paint is used to work into the dark area on the right.

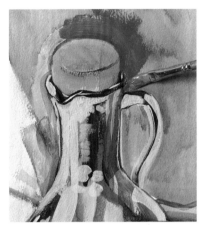

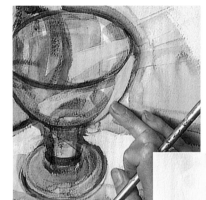

3 The background is strengthened with a thicker application of paint. Using a nylon brush, which is better for precise definition than a bristle one, the artist takes the colour around the edges of the cork and the handle of the carafe.

4 Thicker paint is used for the highlight on the side of the glass. Because it threatens to overlap the edge, the artist pushes it into place with her finger.

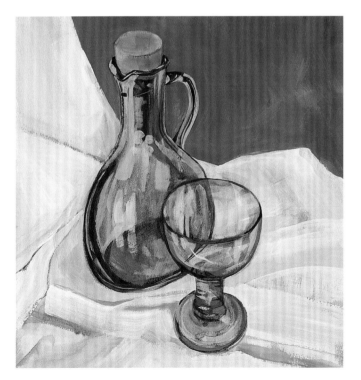

5 In order to achieve the elusive quality of the glass carafe, a glaze of transparent greenish yellow is laid over the original browns and whites. The glaze is applied with a large, soft brush, and the paint is thinned with water alone.

6 The finished painting shows how the consistency of the paint can be varied to suit the subject. On both of the glass objects, opaque highlights overlay transparent washes, while relatively thick paint has been used for the drapery.

Thick paint on canvas

1 The artist began with a careful drawing in water-thinned paint. His preferred medium is oil paint, and he uses the same techniques for acrylic, beginning with fairly thin but opaque paint and building up gradually.

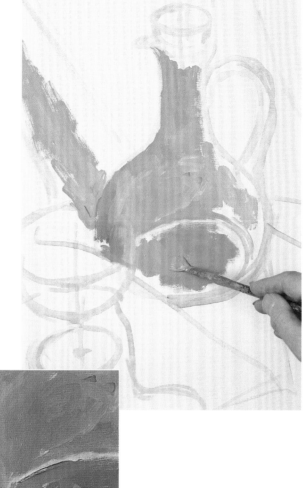

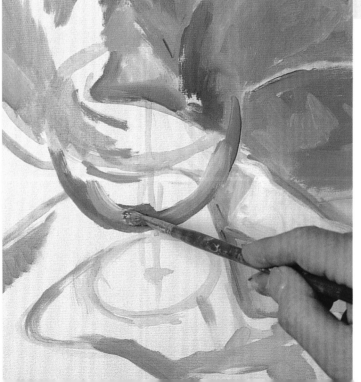

2 He establishes all the main colour areas first, working broadly and attempting no precise definition, although he takes care to keep within the lines of his original drawing.

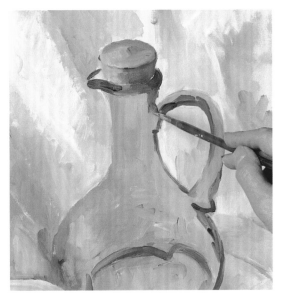

3 A variety of colours has been used for the body of the carafe, and three separate colours for the dark parts of the rim and handle.

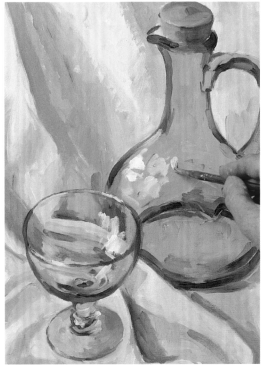

4 The glass is now fully defined, the tricky ellipse at the top having been treated with care. The final stage, often one of the most enjoyable in a painting, is adding the highlights, which bring the whole image to life.

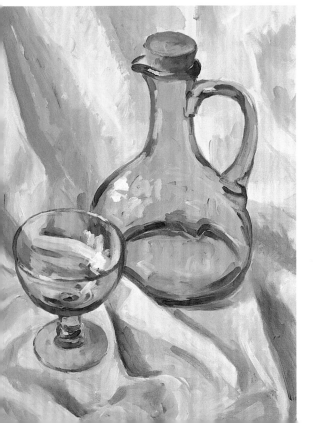

5 Thick paint, varied brushwork and carefully orchestrated colours give a lovely feeling of energy to the subject, and the transparency of the glass is skillfully conveyed.

Transparent paint on paper

1 As in the demonstration on page 72, the artist is working on watercolour paper. She has made no underdrawing because she intends to use transparent paint throughout, and pencil or brush lines could show through in the light areas. She begins with very pale washes, building up gradually towards the darks by laying one wash over another. Using acrylic in this way requires considerable skill, since mistakes cannot be corrected by overpainting.

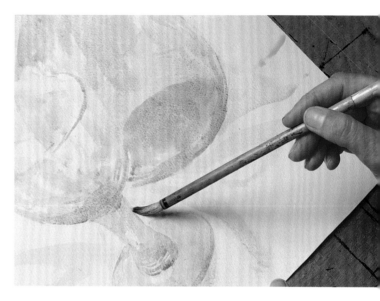

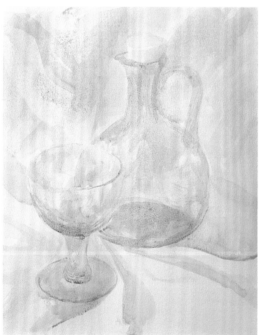

2 At this stage, the painting gives the impression of a ghost image. Certain colours will be strengthened as the work progresses, while others will be left as they are.

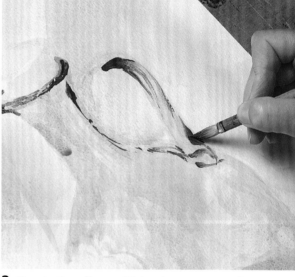

3 Due to the effects of light, the contrasts of tone on glass objects can be strong, with abrupt transitions from light to dark. Here, a dark green is used for the rim and handle of the carafe. The paint is still of watercolour consistency, although there is now a higher ratio of paint to water.

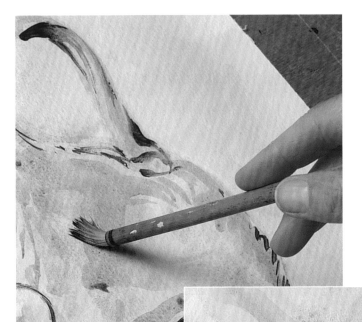

4 Further washes of watery paint are applied to the body of the carafe, building up the effect of the wavy light and dark areas caused by inconsistencies in the thickness of the glass.

5 The finished painting has all the delicacy and translucency of a watercolour, though the colour has a slightly grainier consistency.

Blending

Blending means merging one colour or tone into another so that there are no perceptible boundaries between them. Because acrylic dries fast and thus can only be manipulated on the painting surface for a short time, it lends itself less readily to blending techniques than other paints, but it can be done.

The thicker you use the paint, the longer it will stay wet, making blending easier, but you can prolong the drying time even further by adding retarding medium to the colours as you mix them (see page 20). This will allow you to 'push' one colour into another. Blending can also be done by the dry-brush method shown on the following pages; laying down an area of flat colour and then working over it with a small amount of paint on a bristle brush.

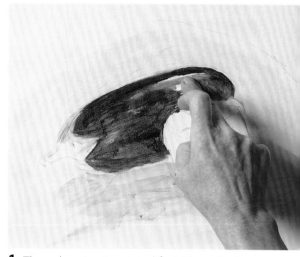

1 The aubergine is painted first. The paint has been mixed with retarding medium, and remains wet for long enough to blend one colour into another with a finger.

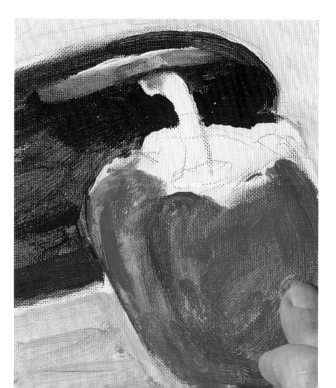

2 Painting the darkest and lightest areas of the aubergine first helped the artist to judge the strength of colour needed for the red pepper, which was initially blocked in with brushstrokes following the forms. Again a finger is used to blend one colour into another.

3 Further dark colours are applied to the aubergine. A nylon brush is used throughout, since this is softer than a bristle brush, and does not leave pronounced brushmarks.

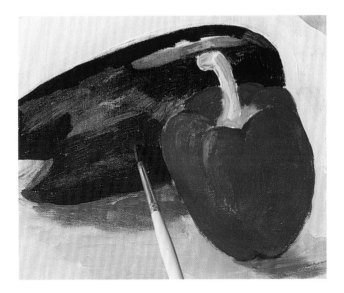

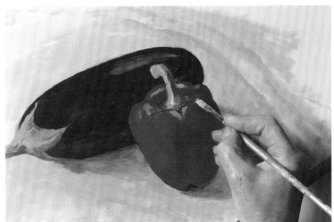

4 Yellow was added to the basic red mixture for the pepper and applied gently onto the side. The retarding medium makes the paint more transparent so that new applications do not completely cover the underlying colours. The highlights, which do not need to be blended, are added with less medium added to the paint.

5 The brushmarks are barely visible, and there is no obvious boundary between each colour and tone. Although retarding medium is helpful, it needs to be used with caution. On a non-absorbent surface, such as primed canvas board, the paint remains tacky for some time, and there is a danger of accidentally lifting off small areas of colour.

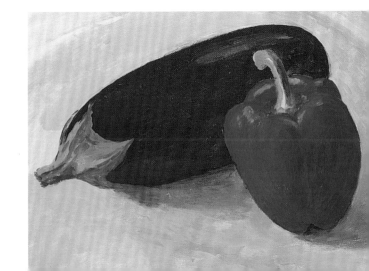

Dry brush

Dry brush is a technique common to all the painting media, whether opaque or transparent. It simply means working with the minimum of paint on the brush so that the colour below is only partially covered.

You can work dry brush straight onto virgin paper or canvas, but it is more usual to work it over a previously laid colour, thus achieving a broken-colour effect.

For thin acrylic, you will need to use a soft brush, ideally a square-ended one, with the hairs splayed out slightly. Experiment on a spare piece of paper beforehand; it is important to get exactly the right amount of paint on the brush or it will go on too heavily and spoil the effect.

If the painting is in thick or medium-thick acrylic it is probably best to use a bristle brush – the fan-shaped ones sold as 'blending brushes' are useful. You can brush equally thick, fairly stiff paint over the underlayer, or use thin paint over thick, depending on the effect you want to achieve.

1 The artist is working on canvas, and begins by giving it an overall tint (see page 37), spreading well-diluted paint with a piece of kitchen paper.

2 Working with a bristle brush, he drags thick paint lightly over the canvas so that some of the warm undercolour shows through.

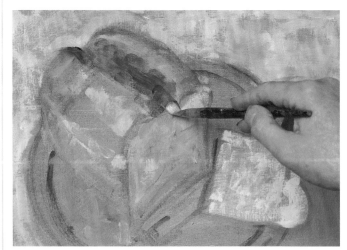

3 The texture of the crusty loaf is accurately represented by successive applications of dry brush. Because acrylic dries so quickly, one layer of paint can be laid over another almost immediately.

4 The edge at the top of the loaf is crisp and clear, so here juicier paint is used, and applied more heavily.

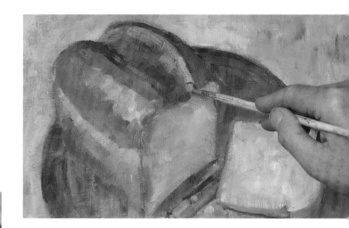

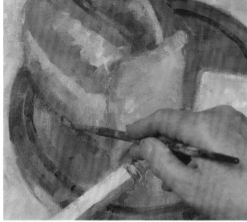

5 On the bread board, considerable variations of colour and tone have been achieved by laying one colour over another. The dry-brush method is again used for the soft, broken line of shadow beneath the loaf.

6 Dry brushing is an excellent method of suggesting texture, and has also allowed the artist to build up subtle but lively interactions of colour.

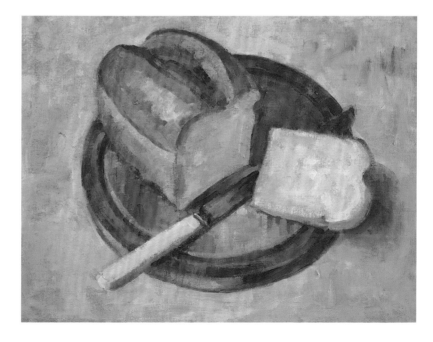

Spattering

Spraying or flicking paint onto the picture surface is an excellent way of suggesting certain textures, and can also be used to enliven an area of flat colour – perhaps in the background of a still life. Watercolour-landscape painters sometimes use spattered paint to convey the crumbly appearance of cliffs and sandy beaches, or spatter opaque white paint to describe the fine spray of a breaking wave.

An old toothbrush is the implement most commonly used for spattering. You can also use a bristle brush, which makes a coarser spatter with larger droplets of paint. Or, for a really fine spatter over a large area, use a plant spray or a spray diffuser of the type sold for use with fixative. In this case, you would need to mask any areas of the work that are to remain free of sprayed paint.

Whichever method you use, it is important to remember that spattered paint frequently lands in the wrong place – on your clothes, the floor and walls and your work table – so it is essential to protect all vulnerable surfaces.

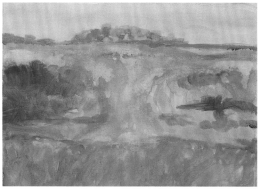

1 The landscape is blocked in simply, with little detail in the foreground, since this will be built up with spattered paint.

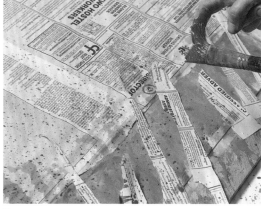

2 A piece of newspaper is placed over the area to be kept free of spatter. More elaborate masks, made from torn strips of newspaper, are also positioned. Red paint is then flicked on using the side of a large brush, which produces a coarse spatter with quite large droplets of paint.

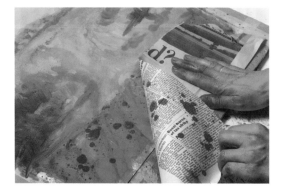

3 The effect can be softened by blotting with newspaper or other absorbent paper. In this case, blotting also produces variations in size, as the paper spreads out the wet droplets.

4 The bush in the middle distance is next to be spattered, again after masks have been placed around the area. Because the bush is further away, the spatter needs to be less obtrusive, so a toothbrush is used, which releases finer particles than a paintbrush. Load it with paint that is well thinned but not too watery, and quickly draw your thumb across the bristles.

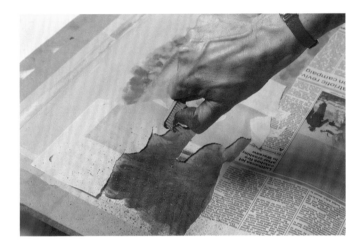

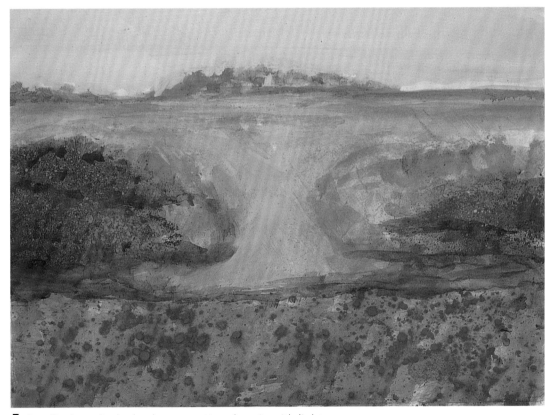

5 As a final touch, the bush was spattered again with light yellow-green and again blotted with paper to merge the drops. The layers of light-brown and bright-red spatter in the foreground suggest flowers and grass very effectively.

Scumbling

This method involves scrubbing an uneven layer of paint over an existing colour.

Whether you choose to scumble a contrasting colour or a similar one depends on the effect you are seeking. You might, for example, scumble several subtle colours over a base coat of mid-grey to suggest the texture of a stone wall, or you might enrich a vivid colour, such as a deep, bright blue, by scumbling over it with shades of violet or lighter blue.

The most important thing to remember is that you should not cover the colour beneath completely, so the paint is usually applied with a light scrubbing action – using a stiff brush, a rag or even your fingers. If you are working on canvas or canvas board, the grain will help you, because the paint will be deposited only on the top of the weave, but scumbling can also be done quite effectively on a smooth surface such as primed masonite (see page 32).

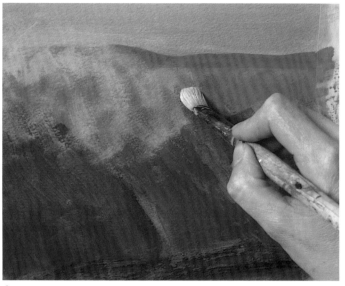

1 An underpainting of relatively flat colour has been made on watercolour paper, and the artist uses a bristle brush to dab and scrub light, opaque paint over the darker colour to produce a veil-like effect.

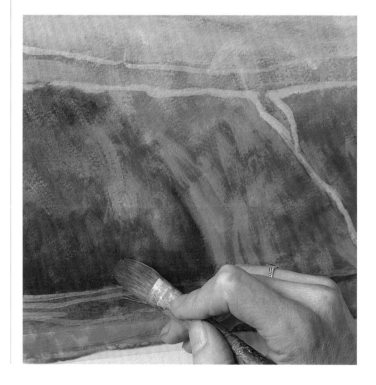

2 After the first layer of scumbling at the top of the picture, the composition has been defined with lines of light-coloured paint. In the foreground, dark red-brown is scumbled over the green.

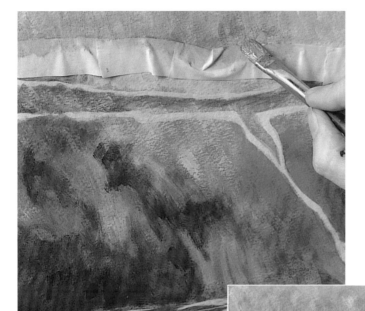

3 Scumbling is an imprecise method, impossible to restrict to a small area, so before turning her attention to the sky, the artist has protected the area by covering it with tape.

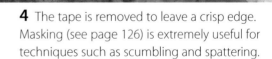

4 The tape is removed to leave a crisp edge. Masking (see page 126) is extremely useful for techniques such as scumbling and spattering.

5 Masking tape was also used to protect the margins of the paper. This results in a perfectly defined straight edge that complements the edge qualities in the painting and contrasts with the soft broken colour of the scumbling method.

Glazing

This is a technique first used in the early days of oil painting, when paint was built up in a series of transparent or semi-transparent layers over an underpainting. Each layer must be dry before the next is applied, so the method is perfect for fast-drying acrylics. The effect of successive veils of colour is quite unlike anything you can achieve with opaque paint, and glazing allows you to build up colours of great depth and richness.

Glazing can be done with paint thinned with water alone, but the colours will be more vivid and more transparent if you use a mixture of water and acrylic medium – either matt or gloss. The layers need not all be uniformly thin; you can glaze a thin layer over impasto, or over an area in which you have built up a heavy texture with modelling paste.

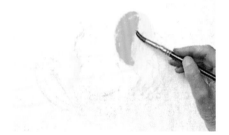

1 Working with a soft brush on watercolour paper, the artist has begun with thin washes of yellow over a pencil drawing. She now mixes the paint with a little matt medium and applies it more thickly.

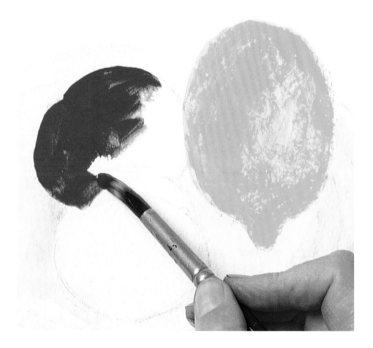

2 The paint is mixed with matt medium throughout, since the picture is to be built up with successive layers of glazes. Notice that the medium makes the paint more transparent.

3 Several layers of semi-transparent colour have begun to establish the form of the plums, and delicate touches of darker colour are now applied to suggest the texture of the lemon.

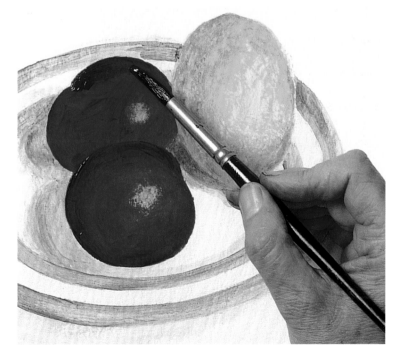

4 A deep, rich purple red is used for the dark area of shadow where the fruit turns away from the light.

Continued on next page

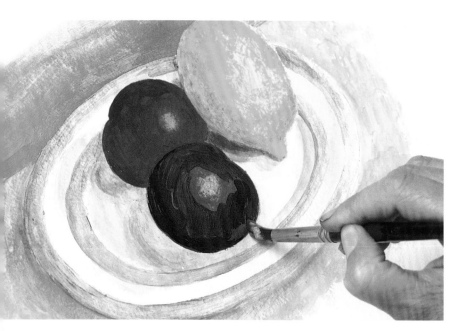

5 For the plum in the foreground, more blue is added to the crimson, producing a very deep but still transparent colour that allows the red to show through.

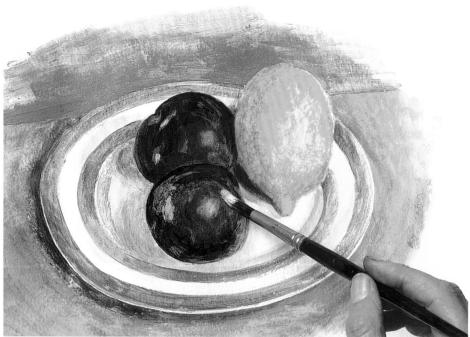

6 The matt medium reduces the 'body' and opacity of the white paint, making it ideal for suggesting the light bloom on the plum. The paint is gently pulled over the paper surface in a scumbling method.

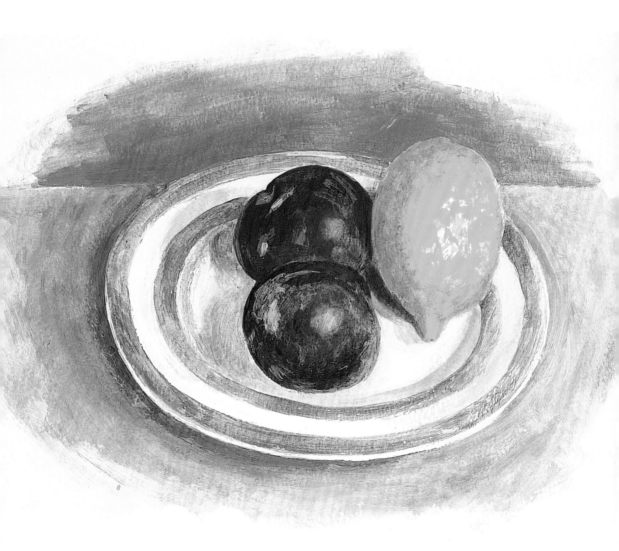

7 The effect produced by this layering technique is very distinctive, with one colour showing through another to achieve subtle and glowing mixes. You can see this particularly clearly on the plums, and on the shadows beside them.

Impasto

The word impasto describes paint applied thickly enough to hold the marks of the painting implement.

Impasto paint can be applied with a brush or a painting knife, or even squeezed onto the painting surface. You can use thick paint all over the picture surface, as Van Gogh did, or reserve it for certain areas. In a still life you might use thin layers of paint for the background and any shadows on the objects, and touches of impasto for highlights or areas of vivid colour.

If you plan large areas of thick paint, you will find it helpful to mix the colours with one of the mediums made for the purpose (see page 20). Some of these bulk out the paint without changing its colour, while others make it more transparent. When using impasto mediums, remember that the palette mixture will dry slightly darker because the mediums are white when wet and colourless when dry.

Impasto under glazing

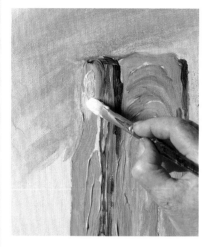

1 Working on primed canvas board, thick paint is applied with a bristle brush over a slightly thinner layer. The paint has been thickened with impasto medium in an approximately 50:50 mixture.

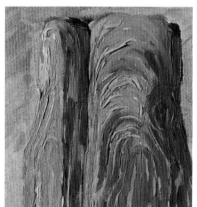

2 In places, the handle of the brush was used to 'model' the thick ridges of paint and push them into place. The paint has also been scratched into with the point of a painting knife.

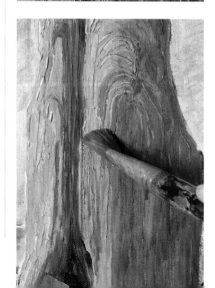

3 A glaze of water-thinned paint is now applied, creating blobs and runnels where it catches on the impasto paint. Any unwanted drips can be mopped up with a rag.

Using gel medium

David Alexander paints large-scale works on canvas, and thickens his paint with a heavy gel medium. Like many painters who exploit the tactile qualities of really thick paint, he employs various unorthodox painting 'tools', among them scrapers, sponges, and hardened brushes. In *The Sun's Recoiled Glare* you can see a contrast of surface textures, with thick swirls of paint in places and sgraffito effects (see page 106) in others.

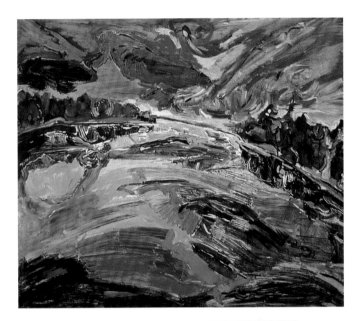

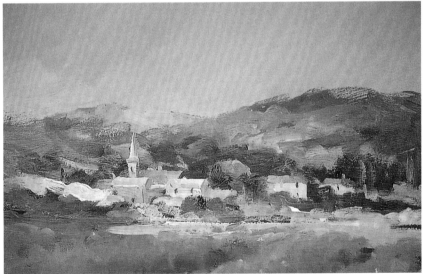

Using the paint consistency

In *Lavender Fields, Provence*, Peter Burman uses paint straight from the tube, that is, not thickened with any medium. Often thick impastos are reserved for foreground details but in this case the blue fields have been generalized in order to give prominence to the sunlit group of buildings, which are skillfully described in a few brushstrokes of thick paint.

Wet-in-wet

When a new colour is applied over a still-wet one, the two will partially mix. This technique is used in both oil and watercolour painting but is trickier in acrylic.

In oil painting, the method was much used by the Impressionists, notably Claude Monet, who painted landscapes on the spot at great speed. Thick acrylics can be used in the same way, but you will need to mix the colours with a retarding medium.

Watercolour wet-in-wet effects can be achieved, as in watercolour itself, by working on damped paper. As long as the paper stays damp, so will the paint. So, if it begins to dry before you have completed an area, simply spray it over with a plant spray. These are useful in acrylic work since you can keep the paints wet on your palette by occasional spraying.

1 Working on well-dampened watercolour paper and using the paint in 'watercolour mode', the artist drops one colour onto another. As she works, she changes the angle of the board to inhibit or encourage the flow of the paint.

2 Before laying washes for the ground area, the paper was dried with a hairdryer to prevent the colours for land and sky merging. It was then dampened again and further wet-in-wet painting carried out in the area of the foreground.

3 The wet paint is now rubbed with a finger to create smeared lines. As long as the paper remains wet, the paint can be manipulated in a variety of ways. The hairdryer is kept on hand for when it is necessary to arrest the paint flow.

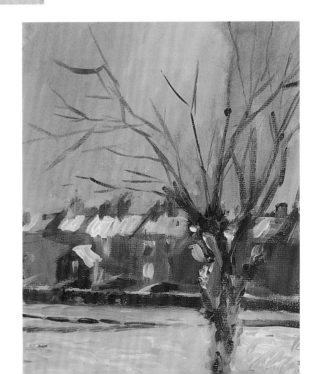

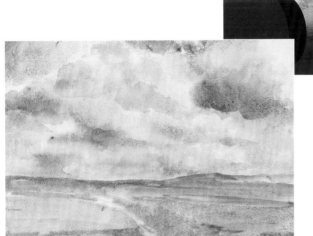

4 Some further work was done on the foreground, and then selected parts of the sky were dampened again to allow the colours of the clouds to be strengthened. Notice the granular effect particularly obvious in the sky. Acrylic used with water alone is prone to 'break up' in this way, though the effect also occurs with some watercolour pigments, and is often encouraged by watercolourists.

Combining methods

In *Well Street Common*, Jane Strother worked the foreground and the snow-clad rooftops wet-in-wet, with retarding medium added to medium-thick paint. She also chose a textured paper to allow her to exploit the dry-brush technique for the tree branches. Notice how the grain of the paper breaks up the brushmarks to give a light, delicate effect.

Coloured grounds

Canvases and boards sold for acrylic painting are usually white, but if you find a white surface distracting you may find it helpful to lay on a tint before starting to paint. There are no true whites in nature, so a white surface provides an artificial standard, making it hard to assess the first colours and tones you put on. There is a tendency to make the first colour too light, since almost any colour looks dark against white, but if you tint the board with a mid-tone, you can work up to the lightest tones and all the way down to the darks.

Colouring the ground is easily done – brush some thinned acrylic all over the surface and it will be dry in minutes. Usually a neutral colour is chosen, such as grey, grey-blue or an ochre brown, which can contrast with the overall colour key of the painting. Artists who work on coloured grounds often deliberately leave small patches of the ground uncovered, which helps to give the picture unity, since repeating colours from one area to another 'ties' the separate elements together.

1 The most usual choice for a coloured ground is a neutral brown or grey, but for this vivid subject the artist has decided on a striking multicoloured ground, which she applies with a large soft brush.

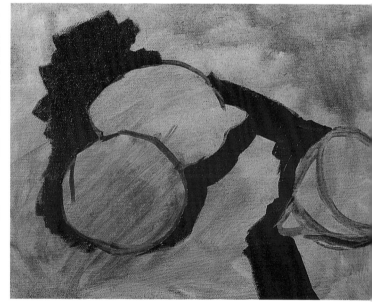

2 The undercolours make it easier to be bold about the darkest tones, and here pure black is used.

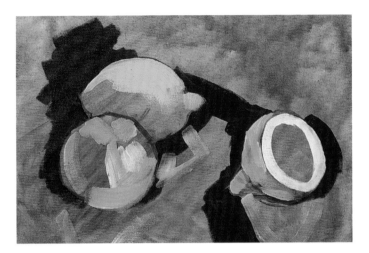

3 The light and bright colours can also be more easily assessed when there is a ground colour, as this provides a middle tone. The reflections have been painted before the black area in front of the fruit; you will see the reason for this in the next step.

4 The black paint is now applied more thinly, in the form of a transparent glaze that will 'knock back' the colours of the reflections without obliterating them. The thin paint also allows some of the ground colour to show through.

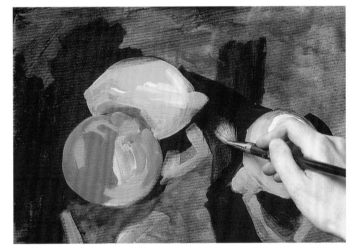

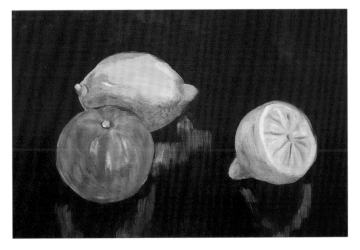

5 Final touches add a little more colour to the reflections and paint the cut side of the lemon. Notice the way the ground colour has influenced the applied colours, with the black glazes over the blues and violets, producing a deep rich purple, particularly noticeable at the top of the picture.

Tonal underpainting

Before the Impressionists revolutionized oil-painting techniques by working outdoors direct from the subject, paintings were built up in layers, starting with a tonal underpainting – usually brown – which then established the whole composition and all the modelling of forms. Colour was applied in the final stages.

Fast-drying acrylic is ideal for such techniques, and some painters have revived traditional oil techniques by building up a whole picture in thin layers of glazing over an underpainting. The method is only suited to studio work, but for any large or complex composition, such as a figure group or highly organized still life, it can be more useful than underdrawing, because it allows you to work out the main light and dark areas.

1 For a painting that is to have a strong tonal structure, an underpainting in black, white and grey can be very successful. The artist begins with a brush drawing.

2 The figure is built up in light grey overlaid with thicker applications of white, which will allow for glazes of light and bright colour.

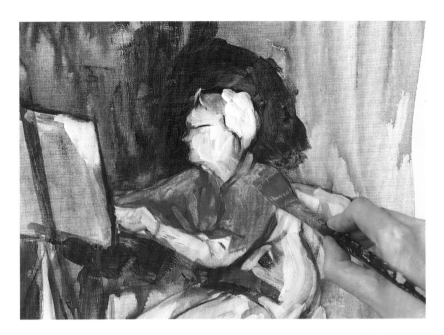

3 The heavy brushstrokes of white show through the transparent red glaze to model the forms. There is little point in making an underpainting unless it plays a part in the finished image.

4 The top colours have been applied thinly everywhere; the modelling on the legs was also achieved by letting the thick, white underpainting show through the watery, blue-grey paint.

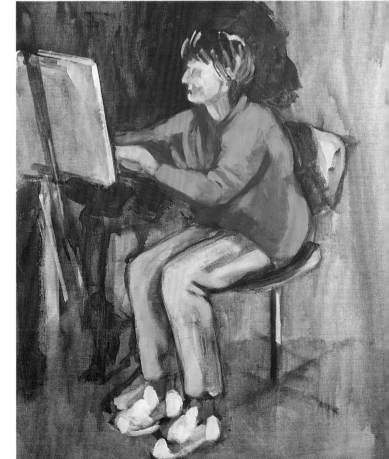

Knife painting

Paint applied with a brush can be thin, thick or somewhere in between. However, paint applied with a knife must always be thick.

Knife painting is a form of impasto, but the effect is quite different from that of thick paint applied with a brush. The knife presses the paint onto the surface, giving a flat plane bordered by a ridge where the stoke ends. In a painting built up entirely of knife strokes, these planes and edges will catch the light in different ways, creating a 'busy' and interesting picture surface. The marks can be varied by the direction of the stroke and the amount of paint, and you do not have to restrict yourself to the flat of the knife – you can flick paint on with the side to create fine, quite precise lines. As with any impasto method, you will probably need to mix the paint with a bulking medium (see page 20), otherwise it will not be thick enough to hold the marks of the knife.

1 A less-experienced artist might need to make an underdrawing to act as a guide for the first knife strokes, but here, the main shape is blocked in with colour immediately. The artist is working on canvas board.

2 The first layer of paint was allowed to become touch dry and a second layer was added with a pointed knife. The first application of paint was pushed onto the surface, so it is relatively flat. The brown has been applied more lightly, creating thick ridges with distinct edges.

3 By twisting the knife slightly as he works, the artist allows the point to scratch into the paint, thus combining knife painting with a version of the sgraffito technique (see page 106).

4 An ordinary, straight-bladed palette knife is now used to remove small areas of the still-wet brown paint, suggesting the buttons on the jacket. Thickly applied paint dries slowly and can be manipulated on the surface for a considerable time.

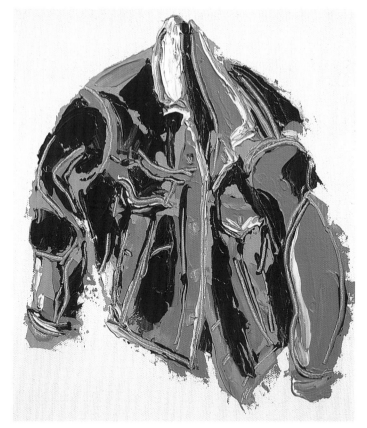

5 Further knife strokes of both black and white paint were added in the final stages to complete the definition of the jacket.

Extruded paint

As well as being applied with knives and other implements, paint can be squeezed onto the working surface from a nozzle. This method is similar to that used by potters, who create raised patterns by squeezing thinned clay, called slip, onto the surface of plates or bowls. It is also, of course, used by cooks for decorating cakes.

You could squeeze the paint straight from the tube, but this will make rather a thick, unsubtle line, so it is best to fit the tube with a nozzle such as the ones used for cake icing. In this way you can draw directly onto the surface. Or you can put the paint into an icing bag, either as it is or thickened with an impasto medium – otherwise you will use a lot of paint.

1 A design – based on a high-heeled boot – was worked out in a sketchbook, and guidelines were pencilled on the working surface (a canvas board). The artist now begins to build up the picture with varying consistencies of paint.

2 By carrying out several stages of painting, the artist gives himself a foundation on which to begin the extruding. This needs a decisive approach, since mistakes can't easily be corrected.

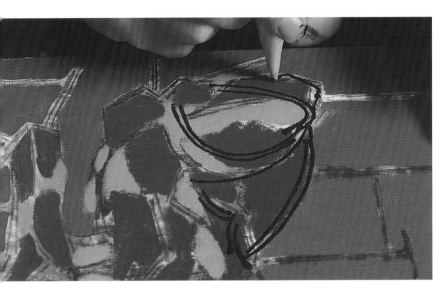

3 Using a piping bag improvised from tracing paper, he begins to outline the toe of the boot with black. He has bulked out the paint by mixing it with impasto medium.

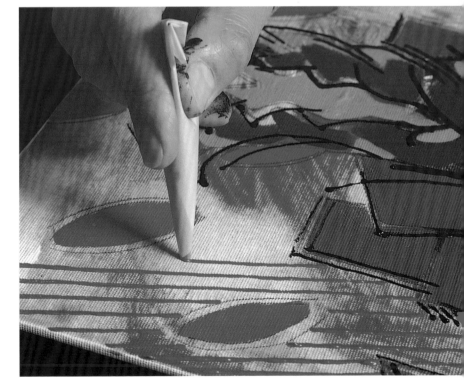

4 Several piping bags are needed for different colours. A new one is used to draw rows of carefully spaced diagonal lines around the painted ovals.

Continued on next page

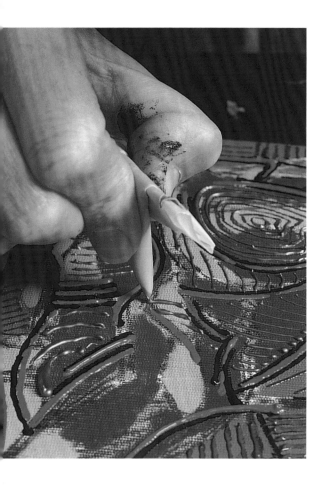

5 The surface is then piped with a network of lines, circles and small dots. Care must be taken not to rest the hand on completed parts of the work, so the board is turned around from time to time.

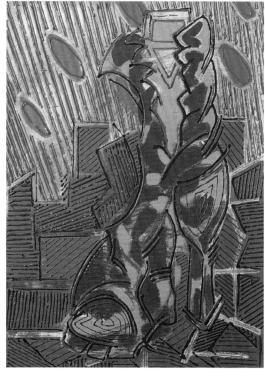

6 The picture is propped up at a distance to assess how much more work needs to be done. The boot clearly requires further attention, because it is less heavily textured than the background.

7 The nozzle of the piping bag has been cut to give a thicker trail of paint, and solid orange lines are made inside the earlier red ones.

8 The same orange was used first to outline the boot and then to strengthen the oval shapes in the background. The rest of the boot was built up with a finer network of lines overlaying the original flatly painted colours.

Stencilling

Stencilling is a masking technique in which paint is applied to certain areas of the image while being barred from others. At its simplest, it involves no more than cutting a shape out of a piece of thin card, acetate film or waxed stencil paper, placing this sheet on the working surface, and pushing paint through the 'hole'. The method is often used for applying decorations to pieces of furniture or walls, and it has interesting possibilities for painting, particularly for any work that emphasizes a flat pattern or the combination of a flat pattern and texture.

The stencil should be relatively simple – a stylized flower or leaf, for example, or one or two geometric shapes. You can repeat the stencilled shape as often as you like, perhaps varying the direction.

1 A shape was cut from waxed stencil paper, and colour is pushed onto the paper with a stencil brush. The stencil paper is held firmly with one hand to prevent it slipping.

2 A new stencil has been cut and a band of yellow laid over the blue. The stencil is now turned around, and a further band of iridescent gold laid down. This only partially covers the other colours, because of its transparency.

3 A third stencil, used first in one direction and then the other, gives two fine lines of red. This colour is opaque, and will cover the blue more strongly than either the yellow or the gold.

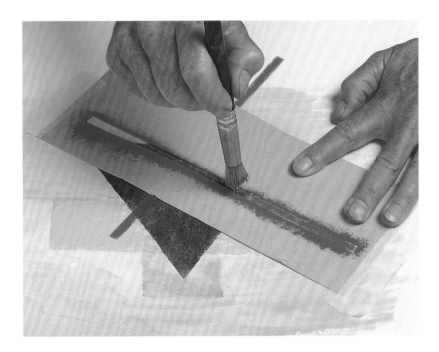

4 One further line of yellow was added to balance the reds, and a light wash was laid over the background. The stencil brush produces a pleasing texture, and the pressure can be varied to create different effects, from solid applications to thin veils of colour.

Sgraffito

The sgraffito technique involves scoring into the paint to reveal either the white of the canvas or board or another colour below. This is another technique borrowed from oil painting. It is slightly trickier with acrylics because they dry faster, and the paint must remain wet long enough for the scratched pattern to be made. However, if you use reasonably thick paint, or mix it with retarding medium, you should have no problems.

You can make a variety of lines, depending on the implement you use and the consistency of the paint. If you scratch into a fairly thin top layer that has been allowed to dry slightly, using a sharp implement such as a scalpel or the tip of a triangular painting knife, the lines will be fine and crisp. Scoring into thick, wet paint with a blunter implement will yield less precise lines, with ridges of paint on each side of them. This can be effective for detail and texture; for example, you might use the method to describe the bark of a tree, hair or the pattern of bricks on a wall.

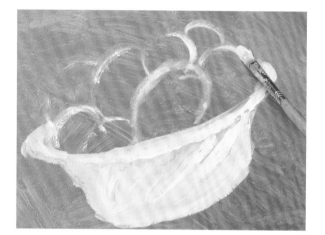

1 Paint can be scratched into to reveal the white surface, but in this case the artist intends to scratch back to another colour. She therefore lays a red ground all over the canvas board before painting the fruit and basket.

2 When painting the blue background, she deliberately leaves a little of the red showing between brushstrokes. She will reinforce this colour contrast by scratching into the blue later.

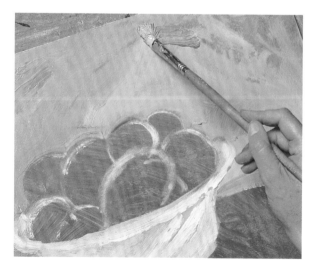

3 She has used retarding medium so the paint is still wet enough to be removed with the point of a knife. If it becomes too dry, harder pressure has to be applied, and this can remove the first layer of paint as well as the second.

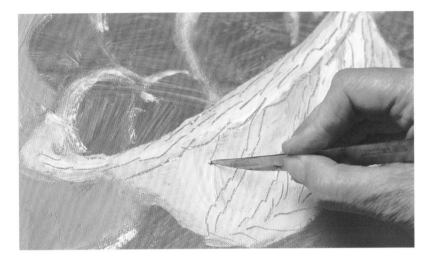

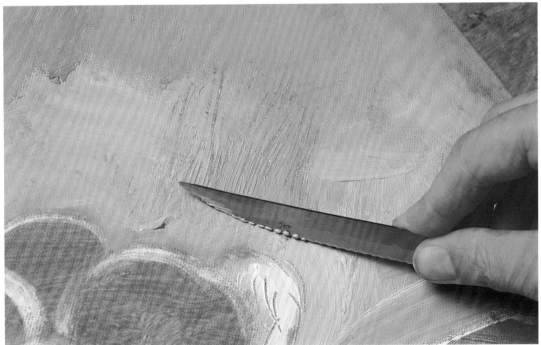

4 Both the point and the serrated edge of the knife are used to create a variety of lines in the blue background. These are echoed by the small areas of red left uncovered by the blue in the first stages of the painting.

Continued on next page

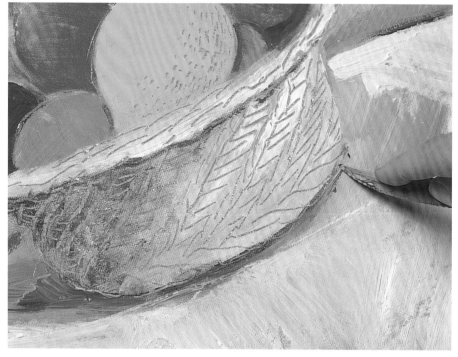

5 With the fruit now painted, the point of the knife was used to pick out dots of red on the lemon. A light glaze was laid to create the shadow on the left side of the basket, and now the pattern is built up with further knife scratching.

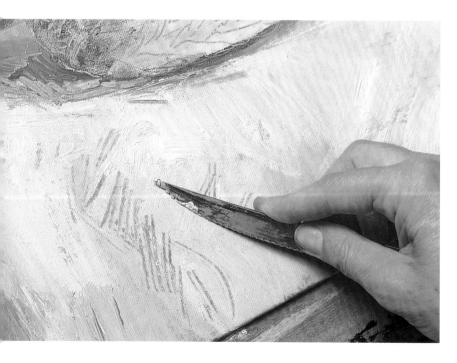

6 To echo the reds elsewhere in the painting and create foreground interest, the tablecloth is also scratched into with the knife.

7 The effect of the painting relies to a large extent on the colour scheme, which has been well chosen to provide blue/red contrasts in each area. The red sgraffito into blue balances the bright colours of the fruit as well as giving extra impact to the scratched lines.

Scraping

Paint can be squeezed onto the surface, applied with the fingers, put on with a painting knife, and it can also be scraped onto the surface. This latter method – which can be carried out with an improvised scraper such as a plastic ruler or half an old credit card, or with one of the metal-bladed tools used for removing wallpaper – is allied to knife painting, but produces flatter layers of paint that cover the surface more thinly. It is thus ideal for layering techniques in which transparent paint is scraped over opaque layers or vice versa. You can also scrape lightly tinted acrylic medium over existing colour, producing a glazing effect that enriches the colour and gives it depth.

1 A plastic card is used to drag paint thinly across the surface. A metal paint scraper can also be used, but the flexibility of plastic makes it more sensitive. The working surface is a canvas board laid flat on a table and secured with tape.

2 A darker colour is laid over the blue. Although the paint is at tube consistency, coverage is thin enough to reveal the colour beneath, and give an effect almost like that of glazing.

3 The greater rigidity of a paint scraper produces thicker, more irregular coverage, a method that is applied in this example to build up surface texture in places.

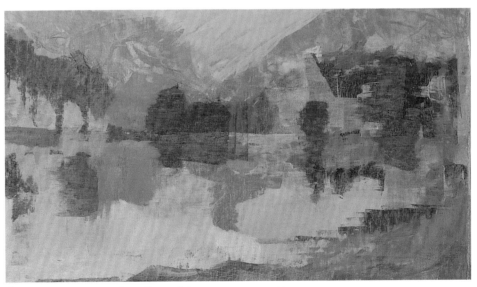

4 Here you can see the effect of the paint scraper (the areas of mountain above the trees at top left) and the transparent overlays of colour achieved with the plastic card.

Continued on next page

5 The card is pulled downwards to create a veil of colour that accurately suggests the reflections. The pigment used in this case is relatively transparent.

6 The foliage on the far bank of the lake is built up more thickly. The paint is the same consistency as before, but instead of being dragged across the surface, it is applied in a series of short, interrupted strokes.

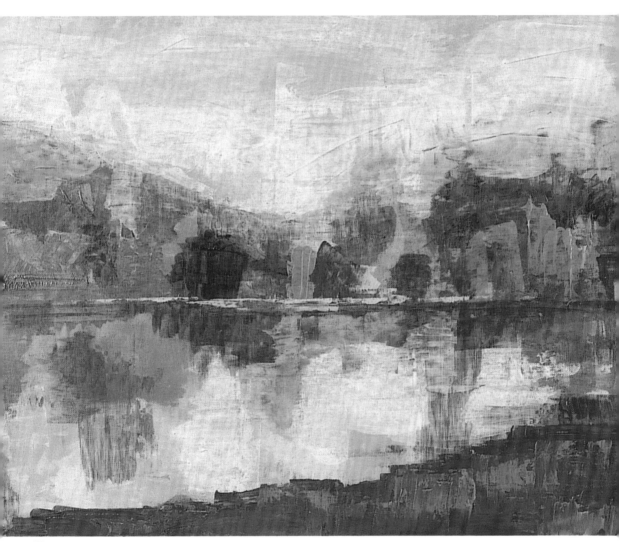

7 The finished painting shows a variety of effects that would be impossible to achieve with any conventional painting tool. Thin veils of colour contrast with discreet semi-impastos and lively edge qualities.

Thin and thick contrasts

As has been mentioned earlier, acrylic can be used like watercolour, with the picture built up from a series of thin washes of colour. The advantage of acrylic over watercolour is that the former is non-soluble when dry, allowing you to superimpose any number of washes – watercolour, however, remains water-soluble, so you can muddy the colours by applying too many layers. For transparent techniques on paper, the best surface is watercolour paper, but these methods are not restricted to works on paper; lovely effects can be achieved by using transparent overlays of colour on canvas. These can be juxtaposed with thicker applications of paint, which creates an interesting spatial effect, since the thicker paint comes forwards in space.

The American abstract painter Morris Louis (1912–1962) worked on raw (unprimed) canvas, using thin, transparent washes to build up overlapping shapes in brilliant, translucent colours. Similar techniques can be used for representational work.

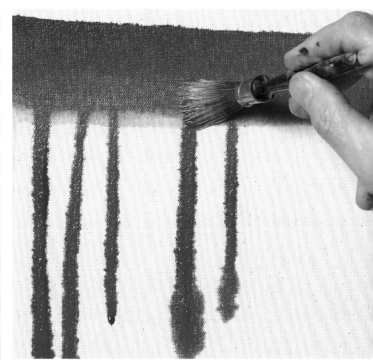

1 The primed canvas has been dampened all over with a solution of warm water and liquid detergent, which helps to spread the colour and gives a soft-edged effect. Colour is spread at the top of the upright canvas and allowed to run down.

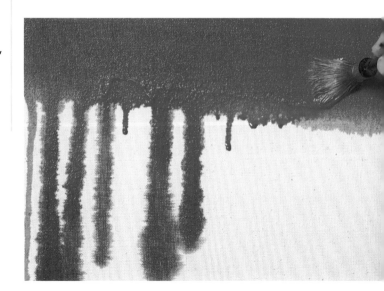

2 A further application of colour blends with the first and creates more runs and dribbles.

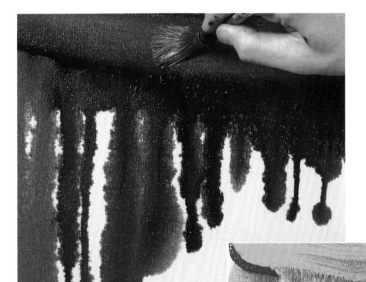

3 The pattern of dribbled colour is built up and strengthened with dark purple. A soft brush is used to lift out some of this colour, creating bands of light and dark.

4 The canvas is now turned upside down, and colour is applied at the top in the same way as before, but rather more thickly; in this case, the artist wants the paint to run right down the canvas.

Continued on next page

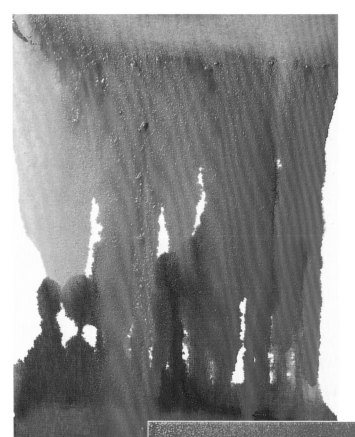

5 Because the photograph was taken when the paint was still wet, the new colours obscure the original purples and reds, but when the paint dries, it becomes more transparent, as you can see in the finished painting.

6 The canvas is turned again, and a new colour is applied and allowed to run. The edge that is at the top at this stage is actually the bottom of the painting.

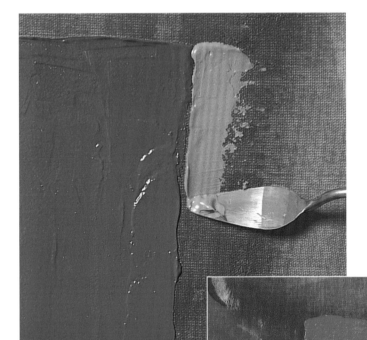

7 In order to set up a contrast that will stress the transparency of the paint, an area of thick, opaque colour is now laid on with a knife (see page 98).

8 Thick paint always has the effect of advancing towards the front of the picture plane, while thin, transparent paint recedes. You can see this effect very clearly in the completed painting, where the rectangle of knife-applied paint seems almost to float above the thin colours.

Texturing the surface

Acrylic excels in the area of texture – there is almost nothing you cannot do with it. Textured effects can be created in many different ways, but acrylic modelling paste, which is specially made for underlying textures, is ideal for the dramatic textures shown here. It can be applied to the painting surface in any way you choose, but you must use it on a rigid surface; if applied to canvas, it may crack. You can create rough, random textures by putting the paste on with a palette knife. You can comb it on to make straight or wavy lines, or dab it on with a rag or stiff brush. And you can make regular or scattered patterns by imprinting: spreading the area with modelling paste and pressing objects into it while it is still wet.

The underlying texture method is usually most successful when the paint is applied in thin glazes – opaque paint over texture can look lifeless. However, there are no real rules in painting, and it is up to you to discover what works best.

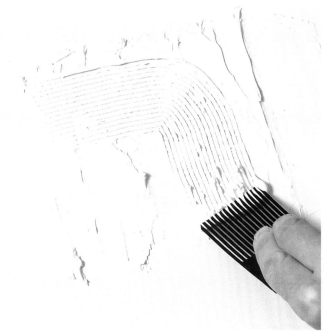

1 Working on heavy white board, the artist spreads acrylic modelling paste first with a palette knife and now with a steel comb of the type made for texturing plaster.

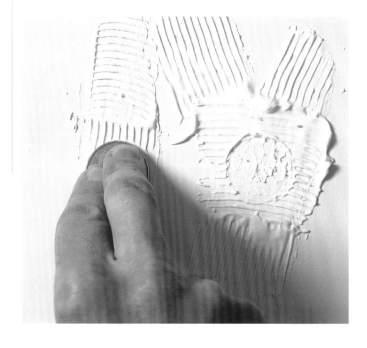

2 Next, he presses a coin into the surface to make an imprint. Modelling paste will remain wet enough for such methods for some time, if used thickly.

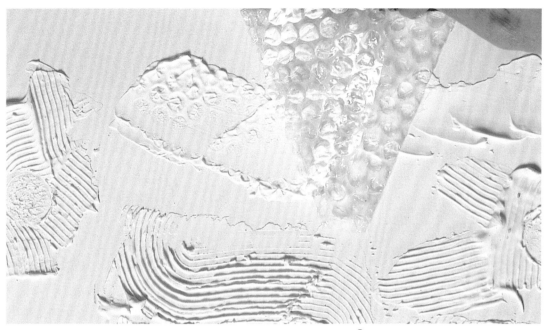

3 Bubble-wrap also produces an interesting imprint. Each area of texture is kept separate, providing what is in effect a series of individual motifs.

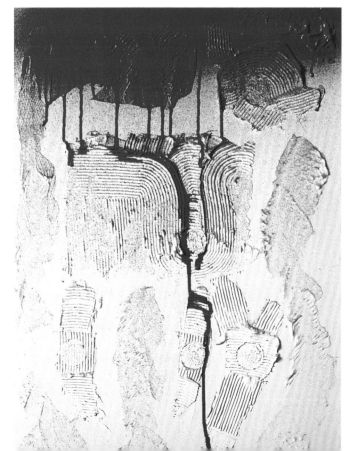

4 When all the motifs have been placed and textured, the whole picture area is sprayed with red liquid acrylic ink (see page 12), using a mouth diffuser. Thinned paint of the same red is now laid in a thick band at the top and allowed to dribble down the surface.

Continued on next page

5 After the paint has begun to settle in and around the troughs of the textured areas, the flow is arrested with a hairdryer.

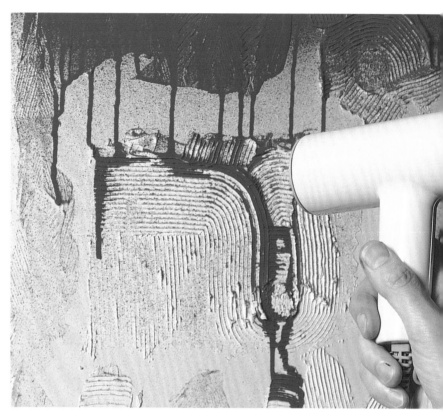

6 Thicker blue paint is now dragged lightly over the red. Notice that in the more heavily textured areas the colour catches only on the ridges.

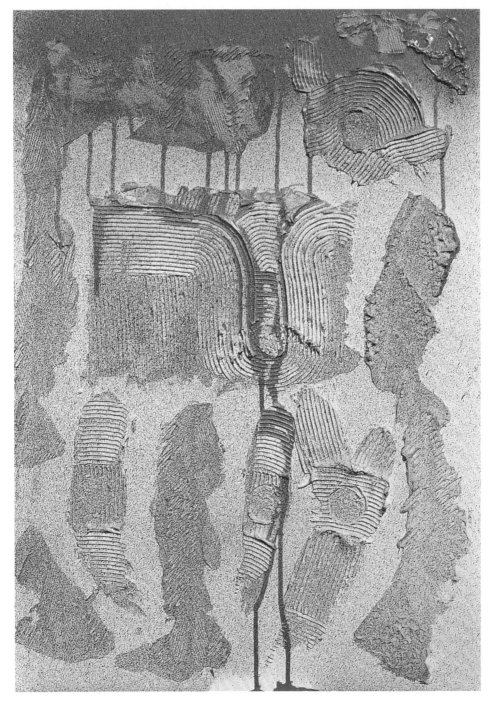

7 The final stage – and one that has completely transformed the painting – is to spray yellow liquid acrylic over the entire picture surface. In terms of colour-mixing, the effect is similar to an overall glaze of colour, the yellow mixing with the red and blue to produce orange and a subtle green-blue.

Wax resist

This technique relies on the incompatibility of oil and water. A candle or waxy crayon is used to scribble over clean paper and a wash of water-thinned acrylic is laid on top. The paint slides off the waxed areas, leaving a slightly speckled area of white. You are not limited to white candle or crayon; you can use coloured oil pastels, or the newer oil bars, which are excellent for wax resist, making a drawing in several colours that can then be overlaid with a contrasting colour of paint.

1 Watercolour paper is tinted with coloured gesso, which provides a slight texture as well as reducing the glare of white paper. A pencil drawing is then made as a guide, and wax applied lightly to the top of the cabbage.

2 The thin, watered paint slides off the wax. Thick paint is less suitable for this method, since the tough plastic skin formed by opaque acrylic can cover the wax completely.

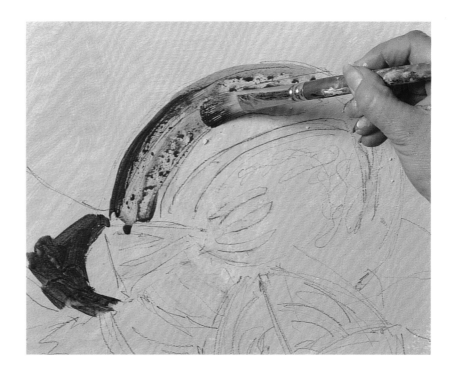

3 Further drawing is done with the sharpened end of a household candle. The coloured ground helps the artist to see where she is putting the wax; this can be rather a hit-and-miss affair on white paper.

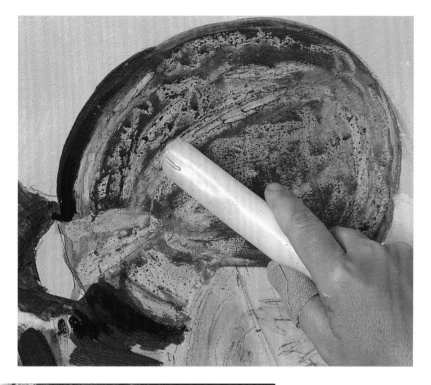

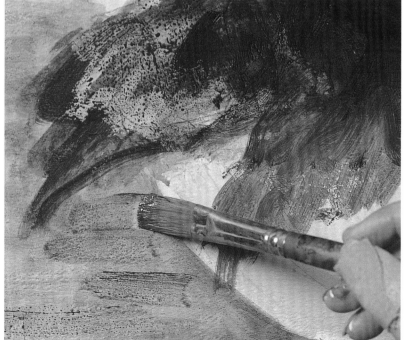

4 Another application of paint builds up the texture, with the paint creating a series of tiny dots, blobs and dribbles as it slips off the wax and settles in the non-waxed areas.

Continued on next page

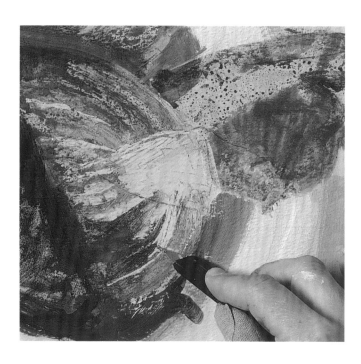

5 To create more precise, linear effects, the point of a knife is used to scratch away the small drops of paint that have settled on top of the wax. The artist has turned the board around to gain access to this area of the picture.

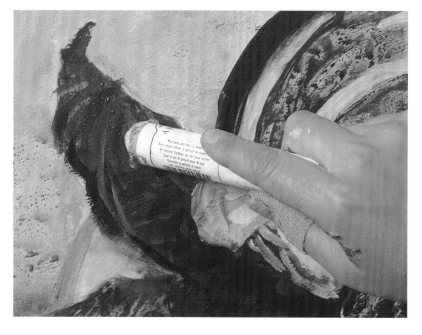

6 A white oil bar is now used to draw over the paint, giving more definition to the cabbage leaf, which was previously rather amorphous. The bar has also been used to try to reinforce the drawing in the centre of the cabbage.

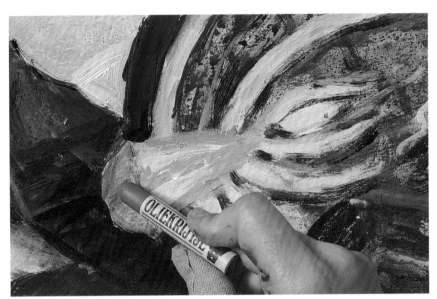

7 Further finishing touches are made with green oil pastel. You can also use oil pastels under the paint, but they are less effective for resist than candle wax or oil bars.

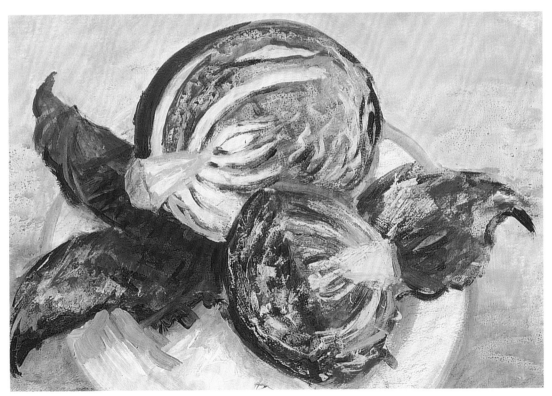

8 The finished picture shows a lively combination of pattern and texture. The oil bar, which has been used on the cabbage and the plate, gives a painterly quality to the image.

Masking

It is extremely difficult to paint a completely clean edge or a perfectly straight line. It can help to hold your brush against a ruler, but the paint tends to slip underneath, so it is better to use masking tape. Masking techniques are often used by abstract painters who want crisp, hard-edged division between shapes, but they have their uses in representational painting also. You might be painting an interior with a window frame, and you could use masking tape to create a sharp division between this and the view outside. Masking tape can be stuck down over thinly applied paint – as long as it is dry – so it can be applied at various stages in a painting.

1 Thin red and yellow paint is streaked onto the surface (canvas board) and allowed to dry before masking tape is applied.

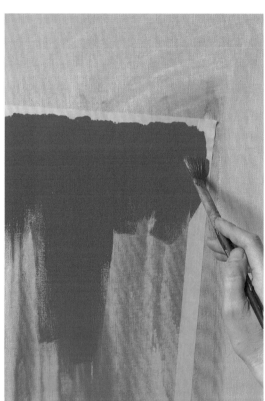

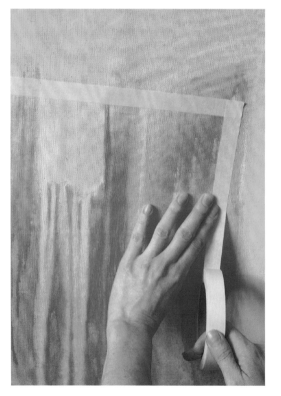

2 The contrast between opaque, flatly applied paint and thinner, rougher applications is to be one of the features of this painting. The brilliant red is applied with a soft brush, which evens out the brushstrokes.

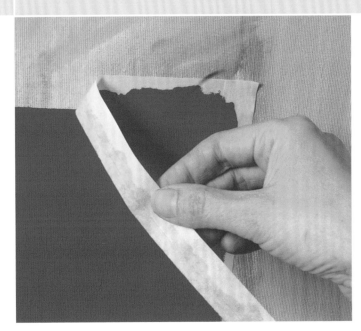

3 The tape is peeled off carefully, leaving a crisp edge. It must be removed before the paint has begun to dry, since the plastic skin that quickly forms will come away with the tape.

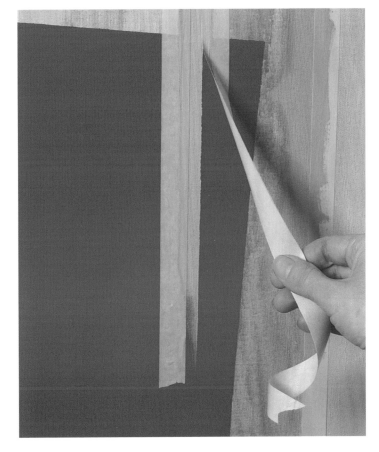

4 The red paint has been dried with a hairdryer, more tape applied, and the area between painted in blue before the tape is again removed. It would be virtually impossible to achieve this thin, straight, slightly tapered line by any method other than masking.

Continued on next page

5 To provide a contrast to the flat area of red, thin purple paint is flicked onto the surface and allowed to run down in dribbles. The artist is working with the board upright on an easel to encourage such effects.

6 Because the purple paint was thin it had seeped under the masking tape. The hard edge is reinstated by painting over it first in white and now in yellow.

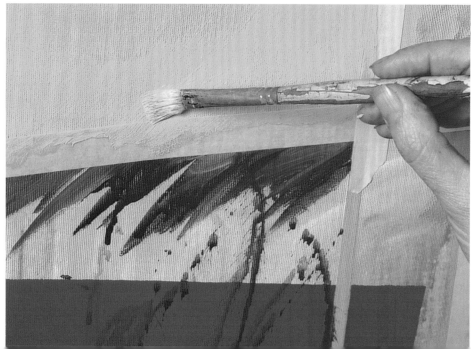

7 The final stage is a thick application of green over parts of the red, applied with a knife (see page 98).

8 To achieve a contrast of shapes and edge qualities as well as of texture, the final green layer is masked at the top only, and then drawn out to form a series of irregular shapes.

Monoprint

Monoprinting is a cross between printing and painting. In true printmaking, a series of identical or near-identical impressions is taken from the same image, while monoprint, as its name implies, is a 'one-off' method. The procedure is simple, and no special equipment is required. A painting – which should be fairly simple and bold – is made on a piece of glass or some other non-absorbent surface. Paper is then laid on top, gently rubbed with your hand, a roller or a spoon, and lifted off. Most of the paint will have been transferred from the original surface to the paper, making the print. Monoprinting can be done with almost any of the painting media, but when using acrylic you will need to add retarding medium (see page 20). If the paint has begun to dry before you put the paper on, it will obviously not make a satisfactory print. You will also need to experiment to find the right consistency of paint; it needs to be fairly thick and juicy, but not so thick that it smudges when you press down the paper.

Single-stage print

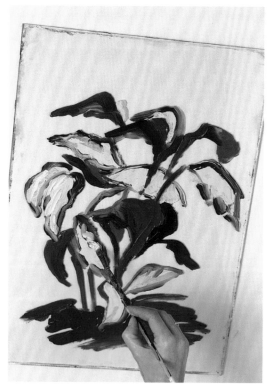

1 Working rapidly to prevent the colours from drying out before the printing stage, the artist paints the image on a piece of heavy glass. Each area of colour is kept separate.

2 Drawing paper is then laid over the painting and rubbed with a spoon to transfer the colour to the paper. The pressure can be varied to create different effects.

3 The paper is now lifted carefully away from the glass. At this stage, it can be replaced and rubbed again if it has not absorbed enough colour, or it can be dampened to encourage the paint to spread.

4 However fast you work, you will find that some of the paint has begun to dry and will print incompletely. However, this can produce interesting results; you can see this 'dry-line' effect on the stems of the plant. The variations in the area of red at the bottom are produced by scribbling on the back of the paper with the handle of the spoon at the printing stage.

Continued on next page

Three-stage print

1 This print is to be more elaborate, with each printing registered (aligned), so a drawing is first made and placed beneath the glass to act as a guide.

2 The first painting stage, which will establish the base colours for the print, is now complete.

3 A print is taken by placing the paper over the glass and rubbing with a spoon. The paper is precisely aligned to the lower left corner of the glass, thus ensuring a correct register for the later printing stages.

4 With the pencil drawing left in exactly the same position as before, a brush drawing is made on the glass, outlining the shapes of the leaves and stems.

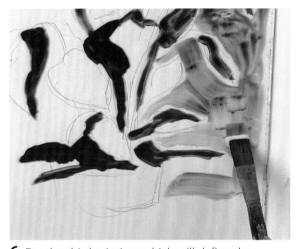

5 A second print is then made with the paper again carefully aligned to the corner of the glass.

6 For the third printing, which will define the shadows, Payne's grey is used alone. Once again, a print is taken over the earlier stages.

7 After the third printing, the image has more depth and definition, while retaining a pleasing softness. Payne's grey is a relatively transparent pigment and has strengthened the earlier colours without obliterating them completely.

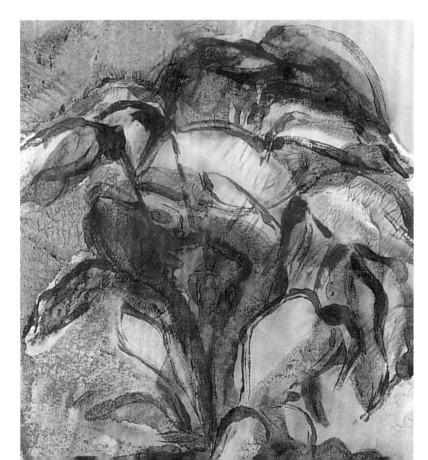

Line and wash

Because acrylic can imitate both oil and watercolour, many oil and watercolour techniques can be adapted to the new medium. Line and wash, a traditional watercolour technique, is one example.

The paint for the washes should be kept thin, or it may detract from the effect of the drawing, so it is best to choose the more transparent pigments. The paint can be thinned with water alone, or with a mixture of water and medium.

The kind of pen you choose will depend on the effect you want. Some line and wash drawings are fragile (the technique is much used for flower studies) while others are bold. Experiment with different pens, from fine nibs to fibre- and felt-tipped pens, or even ballpoints – an underrated drawing implement. You might also try using water-soluble ink, which will spread when wet colour is laid on top, creating soft, diffused effects.

1 Using a fine-pointed reservoir pen, and working on smooth cartridge paper, the artist has drawn in the shapes of the flowers with water-soluble ink.

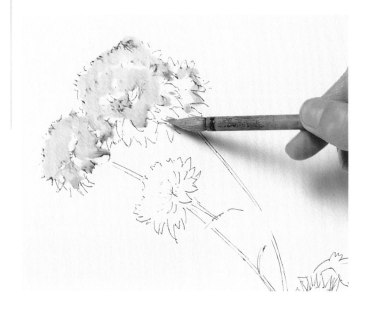

2 With the paint thinned to watercolour consistency, she now touches in colour with a Chinese brush. Because the ink is water-soluble, the wet paint spreads it slightly, giving a soft effect.

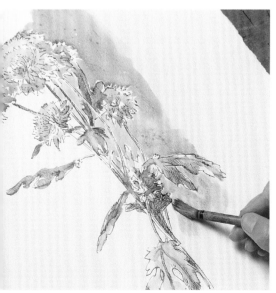

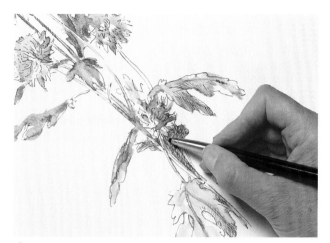

4 The pen is now used in a more positive way to draw into the leaves with diagonal strokes of hatching and cross-hatching.

3 Further details are added with pen, and green washes are laid on the leaves. These mix with the blue ink to create an impression of light shading on the leaves.

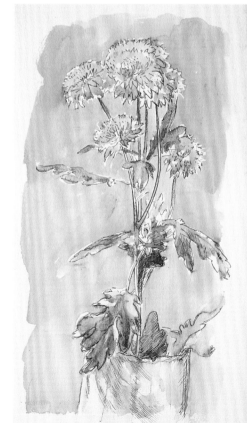

6 To provide a context for the flowers as well as some colour contrast, the background wash is extended, and the top of the vase sketched in lightly with a pen.

5 A light wash is laid over the background and taken carefully around the edges of the flowers.

Pastel and acrylic

Almost any drawing medium can be combined with acrylic, and can either exploit the differences between the media or unite them into a homogeneous whole. An example of the latter approach is the technique employed by some pastel artists of making an acrylic underpainting. Sometimes, the whole of this is worked over in pastel, while at other times parts are left as they are.

Sharper media contrasts can be achieved by starting with acrylic thinned to a watercolour consistency and drawing on top with pastel or oil pastel.

The two media can also be used hand-in-hand. Both acrylic paint and acrylic mediums are excellent fixatives for pastel, so you can build up a painting by a layering method: applying some paint and pastel, then covering the pastel with medium or paint and laying on more. Wet paint or medium can cause the pastel colour to spread slightly, but this gives a watercolour effect at the edge of each stroke that can be very attractive.

1 The composition is sketched out in soft pastel, using a combination of linear and side strokes – those made with the side of a short length of pastel.

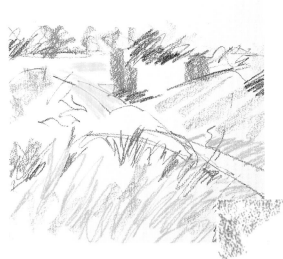

2 A transparent wash of water-thinned paint is brushed lightly over the pastel. Because the paint forms a plastic skin, it fixes the pastel, allowing you to work on top with no risk of smudging.

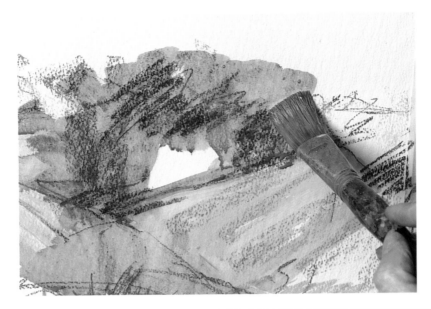

3 Further washes are now laid over the background area. The artist develops the two media together, so that the painting has a unity of technique from the outset.

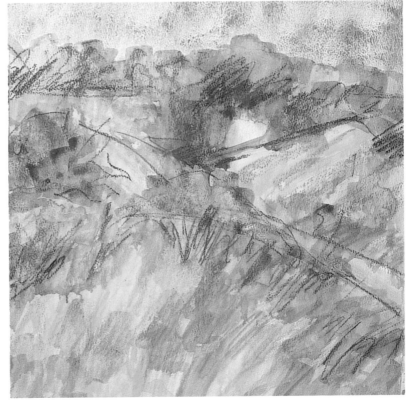

4 At this stage, the effect is similar to that given by the line and wash method (see page 134), with paint of a watercolour consistency laid over the pastel marks.

Continued on next page

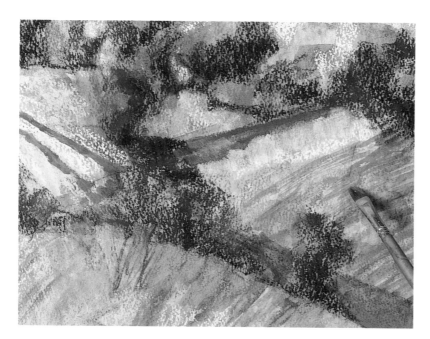

5 The artist continues to build up the painting with both paint and pastel. Because the watercolour paper has a slightly rough surface, it breaks up the pastel marks to provide a broken-colour effect.

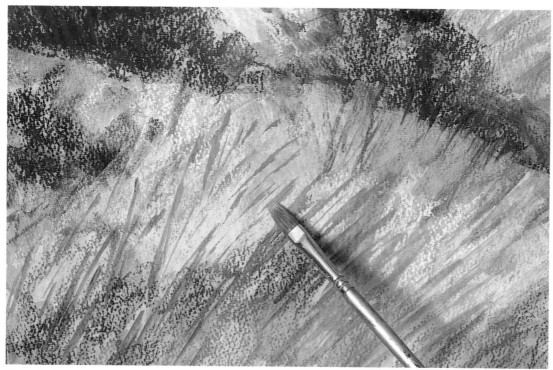

6 In the foreground, linear strokes made with the edge of a nylon brush complement the previously made pastel marks.

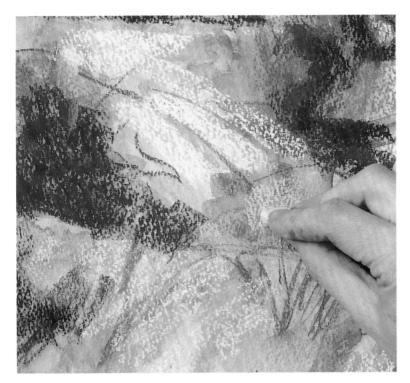

7 The side of the pastel stick is dragged lightly over dry paint, creating a subtle veil of colour. This area of the painting – the middle distance – requires a softer treatment than the foreground.

8 The finished painting is a good example of a successful 'marriage' of media. Although there is a contrast of textures, no one area can be singled out as being either paint or pastel.

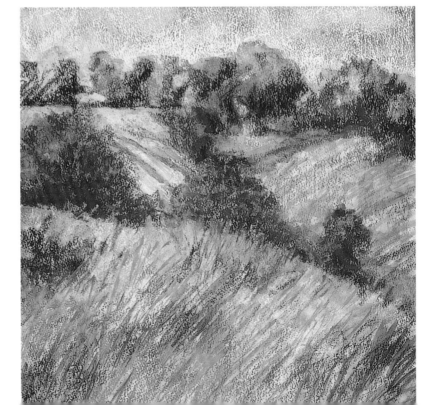

Charcoal and acrylic

Since acrylic paints can be used thinly on paper, very much like watercolour or gouache paint, it follows that you can combine them with any drawing medium that you would use on paper.

Charcoal is, in itself, a versatile medium, capable of producing both fine lines and rich areas of tone. By combining it with acrylic, you can achieve a wide range of exciting effects.

There are many different ways of working. For a portrait you might map out the composition with charcoal, using it also to block in the background, then paint the face and head before working into this with more charcoal. For a landscape you might begin with loose overall washes of colour, and then use charcoal to define detail and build up areas of darker tone.

1 The artist has begun with loose washes of colour, keeping the paint fairly thin, and now uses a stick of thick charcoal to draw over and into the paint.

2 The paint is built up more thickly, laid around and between the charcoal lines on the patterned fabric. While still wet, the whole of the left side of the picture is sprayed with water, using a mouth diffuser.

3 In this detail, you can see the effect of the water spray, which has created a soft, granular texture. The paper is allowed to dry before the artist continues working into the paint with the charcoal.

4 The charcoal drawing on the fabric is now complete, and a small bristle brush is used to dab in touches of magenta. This brilliant colour provides a balance for the hot colour of the suitcase, which might otherwise have been seen as too dominant.

5 Finishing touches are the addition of highlights on the metal fitting of the suitcase and some further charcoal drawing on the table.

Oil and acrylic

Mixtures of oil and acrylic must be handled with care, because oil and water are incompatible. This does not matter if the oil colour is used over the water-based acrylic, but if water-based paint is applied on top of oil, cracking will occur. This might not be immediately apparent; if you use the acrylic thickly it could seem to be going on normally, but it would be unlikely to stand the test of time.

However, acrylic can be used quite safely for the first stages of a work to be completed in oil. This can save a good deal of time for any picture to be built up in layers over an underpainting, because the first applications of colour will dry much faster than oils.

You can also cover any kind of acrylic texturing with oil paint, or contrast areas of acrylic with areas of oil. Such methods could be used in collage work, where a lively picture surface produced by contrasting textures is often a feature.

1 Broad areas of tone and colour can be established very quickly with an acrylic underpainting. The paint has been applied flatly for the background, since the textures are to be built up with thicker brushstrokes of oil paint.

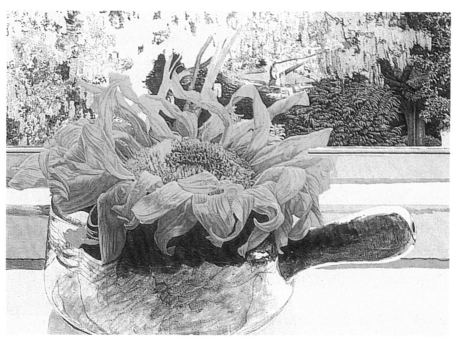

2 The artist has now begun to apply oil paint over the acrylic. The sunflower was not underpainted, but reserved as white canvas in order to increase the brilliance of the yellows.

ARTIST'S TIP

Unless you want to make a feature of texture it is best to keep the acrylic underpainting fairly thin, otherwise it may be difficult to cover with the oil paint. It is normally best used to establish tones or colour. However, a textured layer of acrylic could be a basis for thin glazes of oil.

Pencil and acrylic

Pencil can be used under washes of acrylic colour or on top of paint that is transparent or opaque. If you are using transparent techniques, one of the problems inherent in acrylics can be used to advantage. For watercolours and for watercolour effects in acrylic, you need a good underdrawing. In actual watercolour work, this can be erased after the first washes are in place, but this is not possible with acrylic, which acts as a fixative on the drawing. So try making the drawing a part of the picture from the start, laying colours over and around pencil lines and adding pencil as the picture takes shape.

Opaque paint will, of course, obscure your original drawing, but you can still use pencil on top. How much you use and in what way depends on the effect you want to achieve: you might reserve the pencil drawing for small areas of detail or pattern, or for parts of the picture that are easier to draw than to paint, such as flowers, stems, the edges of leaves or facial features.

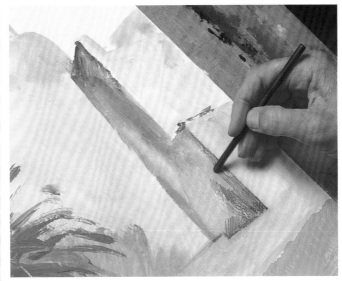

1 The shape of the building is blocked in with thin paint, and the artist begins to draw into it as soon as it is dry, using a graphite stick – a pencil without the usual wooden casing.

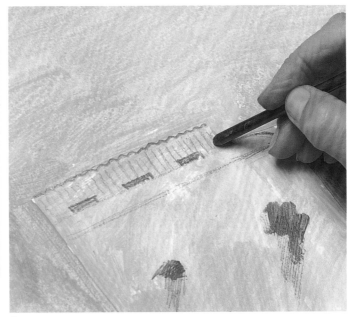

2 Having applied a loose blue wash for the sky, she now starts defining the details at the top of the tower. Graphite (or pencil) is excellent for this, and much quicker than working with paint and a small brush.

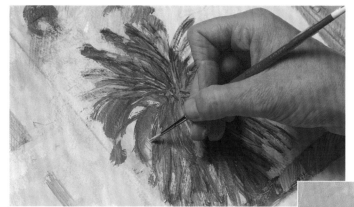

3 The shapes of the palm leaves have been built up with a mix of brushstrokes and graphite drawing. Now a small brush is used to pick out some highlights with pale blue-grey paint.

4 The rough stonework (on the left of this photograph) and the graphite stick come into play again for the shadow below the small outgrowths of shrubbery.

5 In the final stages, more graphite drawing is done on the building, giving an accurate impression of the textures of the old plaster and stonework. The drawing, the light colours and the free brushwork in the sky all contribute to the atmosphere.

Watercolour and acrylic

Watercolour painters often use a touch of 'body colour' (opaque paint) here and there, perhaps to sharpen a foreground, to add white highlights, or simply to correct a mistake. Usually, gouache paint is used, but acrylic is a better choice, since it does not give such a flat, dead surface.

Paintings that are officially classified as watercolour in exhibition catalogues frequently include acrylic, and if the acrylic is used skillfully, it is often impossible to tell which is which. The trick is to reserve the pure watercolour for any areas that need its particular translucent quality, and to use the acrylic fairly thinly – it should be capable of covering colours below, but should not stand out from the surface. In a landscape with grass and trees in the foreground, for example, you would use pure watercolour for the sky and the far distance, and acrylic, either on its own or over watercolour washes – for the foreground and perhaps any areas of texture in the middle distance, such as a wall or group of houses.

Combining media

Hazel Harrison's *View Over Ullswater* was planned and begun as watercolour and had reached an advanced stage before it became apparent that things were going wrong, particularly with the foreground and the tree on the right. Rather than abandon it, the artist decided to carry out a rescue operation with acrylic, thinned with both water and matt medium to reduce its opacity.

Acrylic was used only for the problem areas of foreground and tree, both of which lacked definition. The effect is very similar to that of watercolour thickened with white gouache, but the artist is accustomed to working in acrylic and finds it easier to handle.

Collage

The word collage comes from the French *coller*, to stick, and it describes a picture made by gluing pieces of coloured paper, fabric, photographs, newspaper clippings – or anything you like – onto a working surface. These can be combined with paint, or the whole composition can consist of glued-on fragments.

Acrylic is the perfect medium for collage work. Both paints and mediums have powerful adhesive properties and are capable of securing quite heavy objects to the picture surface. If you use the modelling paste (see pages 20 and 118) and press objects into it – these might be shells, scraps of tree bark, grasses, or even beads or small pieces of jewellery – you can create three-dimensional effects akin to relief sculpture.

Alternatively, you can use paint and paper alone, placing the emphasis on two-dimensional pattern and the juxtaposition of colours. Some artists employ a layering technique, gluing on fragments of coloured paper with acrylic medium, covering these with paint and medium, then repeating the process. Others will begin painting and then collage certain areas.

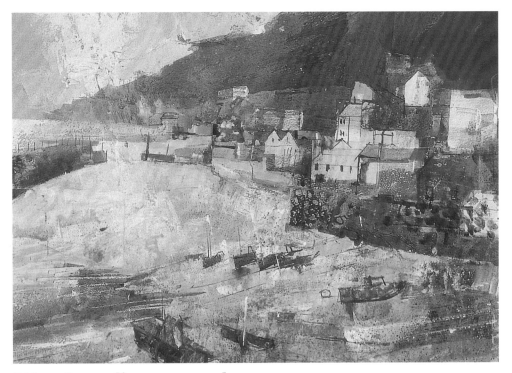

Mixed-media approaches

Although Mike Bernard's painting on paper, *View of Mousehole*, contains elements of collage, the artist prefers to describe it as a mixed-media painting, because he does not rely on collage alone to produce areas of texture. He has combined collage with pastel, paint and coloured inks, applied with a number of different tools, such as rollers, sponges, toothbrushes and palette knives.

Tissue-paper collage

Jill Confavreux's painting *Winter Lake* evolved as part of a series on the theme of frozen ground. The working surface was a medium watercolour paper, onto which the artist glued acid-free tissue paper with gloss medium. This texture formed a textured 'ground' over which she painted and poured acrylic glazes, followed by a light scumble of gold and silver oil pastels. These acted as a resist (see page 122) for further applications of paint, creating an exciting and unusual range of effects.

Surface texture

Jacquie Turner has used collage in certain areas of *Chiswick House Grounds* to create additional texture, which is always an important element in her work. Pieces of glued-on tissue paper are combined with acrylic paint and coloured inks, watercolour, gouache and pastel.

4
Subjects

Landscape **Trees**

Trees can be some of the most exciting features of landscapes, inviting a number of treatments. Tall trees in the foreground of a landscape, for instance, allow you to introduce a pattern element, contrasting verticals and horizontals; while massed trees in the middle distance create satisfying tall or bulky shapes, and often an array of contrasting colours.

Trees can also be appreciated for their varying textural qualities and painted from a close viewpoint – tree barks, for example, provide a wealth of fascinating detail as well as rich variations in colour.

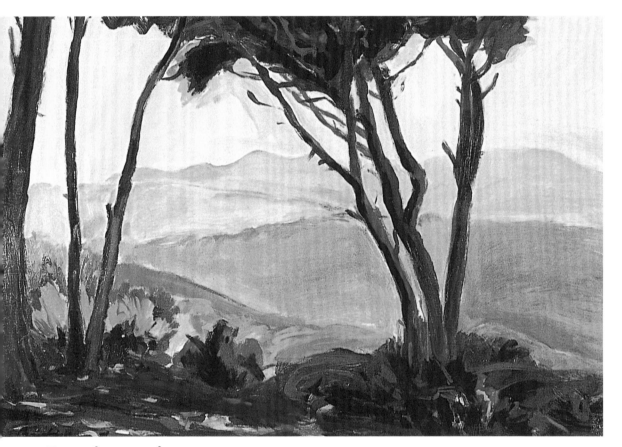

Framing a view

The focal point in Gerry Baptist's *Italian Trees* is the distant hills, and the artist has employed a classic compositional device to emphasize it: using the dark foreground trees as a frame within a frame. This also increases the sense of space, since the cropping of the trees at the top brings them to the front of the picture, pushing the hills back.

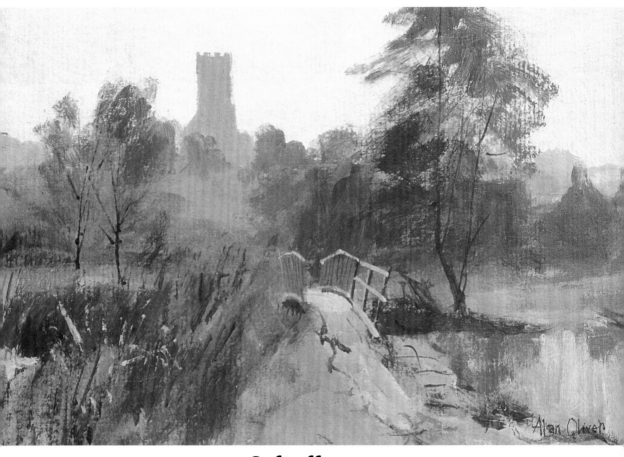

Soft effects

Coloured and textured mount board without priming was used for Alan Oliver's *Glandsford Church*. The artist likes a slightly absorbent surface, which allows him to exploit dry-brush techniques: notice how the paint has been dragged lightly over the surface to achieve the soft effect of the trees. Apart from the sky, which is a thin wash of colour, the paint has been used straight from the tube with no water or medium added.

Continued on next page

First-hand observation

Paul Powis does not restrict his outdoor work to the summer months, and these evergreen trees were painted on the spot during winter. There is a strong pattern element in *West Malvern Spring*, with an exciting interplay of diagonals and verticals offset by intricately shaped areas of bright and dark colour. The clumps of foliage have been defined by painting the sky around them last, light over dark.

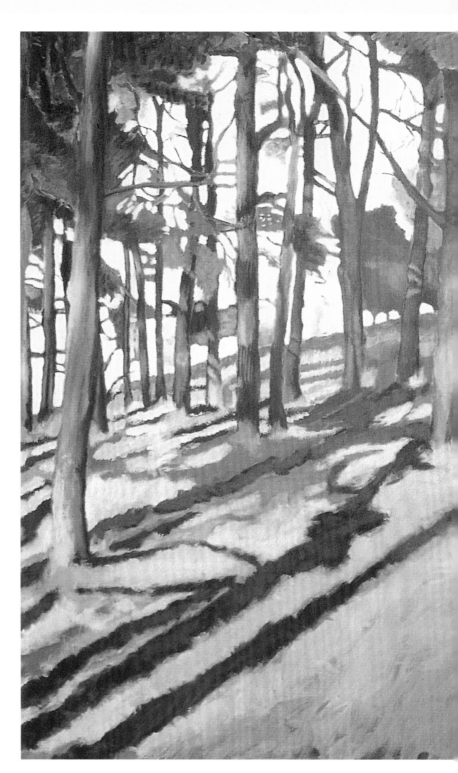

Creating impressions

Although there has been no attempt to describe the trees in detail, they are completely convincing in Geoff Pimlott's *Hillside Fields*, with the impression of the foliage built up through directional brushstrokes. The painting, on primed canvas, was worked in the studio from sketchbook drawings.

Descriptive paint

The tree trunk in Ted Gould's *Spring*, which forms a dramatic foreground to this painting on canvas, has been beautifully observed and described – notice the variety of colours in this one area, and the fine marks made with a small brush to suggest the texture. The foliage of the left-hand tree has been painted with small strokes of impasto over thinner paint.

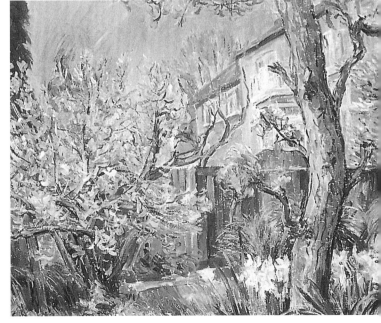

Landscape **Hills and mountains**

In flat landscapes, the sky often plays a major role in the composition; indeed this pre-eminence of sky is part of their appeal. Hills and mountains, however, will always dominate a composition, with the sky playing a minor part, if any. The shapes they create are a gift to the artist, from the gentle curves of downland to the jagged formations seen in cliffs or high mountain ranges.

Fast-drying acrylics are ideal for crisp, positive effects, allowing you to exploit edge qualities to the full, either with successive, overlaid thin washes or thicker applications of paint laid on with a brush or knife, and left unblended. For the softer effects of hills, try letting your brush follow the direction of the curves, both to build up the forms and to create a feeling of movement.

Colour unity

Judy Martin's large painting on paper, *Downs View 1* was done in the studio from sketches, which allowed for a more personal and interpretative use of colour than is usually possible when working on the spot. It can be difficult to paint a sky yellow, for example, when faced with the blue or grey reality, but in this case it was the right choice, since it echoes the foreground yellow to unify sky and land without in any way interfering with our perception of the landscape.

Stress a focal point

Working on watercolour paper, Helena Greene has concentrated on the pattern of angular shapes made by the play of light on the mountains. The deep purple-blue of the sky forms a dramatic backdrop, and the dark shape in the centre of the road echoes those of the mountains, providing a lead-in to the focal point of *The Karakorum Highway*.

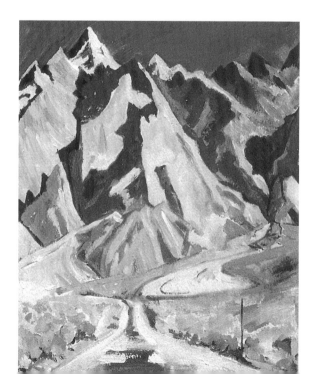

Exploring colour

Jill Confavreux's *Himalyan Poppyscape*, in acrylic and collage with oil pastel, evolved from the idea of exploring the colour blue through many different textures of paint and paper. Working on watercolour board, the artist began with a series of acrylic glazes, encouraging the colours to run and mingle. The paper for collaging – Japanese Hokai paper and tissue paper – was then painted in turn before being stuck down with gloss medium, left to dry and scumbled over with oil pastel. The artist then added more acrylic glazes, and cut back into the board in places to create a different surface for further applications of paint and oil pastel.

Landscape **Water**

Perhaps because of its unique qualities of being both a transparent substance and a mirror, water has always fascinated artists – lakes, rivers and seas are among the most popular of all landscape subjects. A still lake, gleaming pale blue or silver-white in the reflected light from the sky – even if it is only glimpsed in the distance – can provide a centre of interest for a landscape painting, while reflections, or the patterns made by moving water, can form the main subject.

Creating movement

The choppy water and the movement of the boats in *Sigmas Racing* are conveyed through inventive and varied brushwork, finger smudging and scraping. Jacquie Turner likes to work on smooth paper so that she can move the paint around, and she combines standard acrylic with 'liquid acrylic' inks, watercolour and touches of collage.

Mixing media

In *Lily Pads: Frog Pond in October*, Simie Maryles has used a combination of acrylic and pastel, working on heavy illustration board. Many different colours have been used for the water, and the deep, brilliant blue in the immediate foreground helps to bring this area of the painting forwards.

Simplification

The brilliant blue of the water combined with the contrasting red-brown reflections in Ted Gould's *Autumn Scene* form the centre of interest in this attractive painting on canvas board. The paint has been used thickly, mixed with a retarding medium, and the colours have been simplified into bold blocks for maximum impact.

Continued on next page

Foregrounds

In this on-the-spot sketchbook study, Gerry Baptist has made the bold decision to leave the foreground blank, save for a hint of yellow reflected from the sky and a small patch of darker ripples on the left – which brings the area into focus. There is just enough movement on the water surface to blur the reflections of the trees, which are treated with horizontal brush-marks, in contrast to the more energetic marks used for the trees themselves.

Descriptive marks

Lively, active marks are used throughout Jacquie Turner's *Along the Thames from Under Richmond Bridge 1*, integrating the water and reflections with the boats and trees. The artist has combined acrylic in both pot and tube form with a number of other media, including watercolour, chalk, wax crayon and fabric paint, and has worked on smooth-surfaced watercolour paper.

Tutorial **Acrylic and oil pastel**

A marriage of acrylic and soft oil pastel is skillfully exploited in this lovely evocation of a woodland landscape by Debra Manifold. It has been done from a photographic reference, but with a considerable input of memory and experience.

1 A ground of tinted acrylic gesso is laid on white canvas board to 'cut' the white and provide a light texture, always important for work involving the use of pastels.

2 Working initially in only two colours, the artist establishes the 'skeleton' of the composition and sets a key for the colour scheme. The yellow and purple, although they will be modified later, will both play an important part in the finished painting.

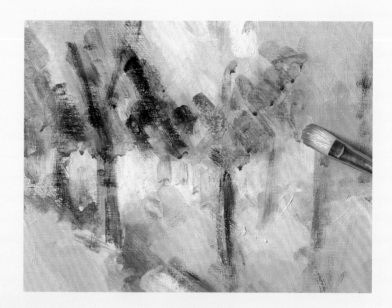

3 An irregular horizontal band of white has been scumbled lightly across the painting over the original colours, and transparent blues and greens are now applied on top, using bold directional brushstrokes.

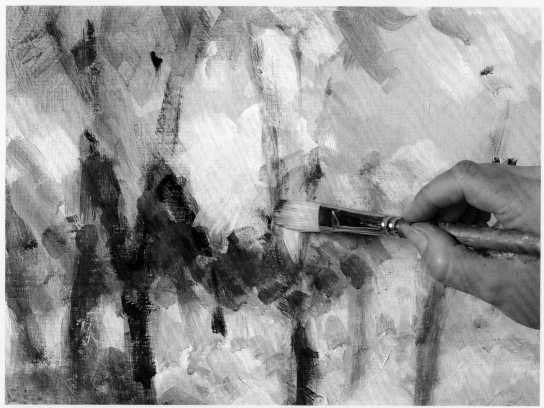

4 The brush is drawn lightly down the canvas in a dry-brush method to achieve a delicate broken-colour effect. This thin coverage of paint also facilitates the later application of pastel.

Continued on next page

5 Strokes of white pastel are now applied, taking care that the marks of the pastel stick complement the earlier brushstrokes. The very soft oil pastel creates a painterly rather than a linear effect.

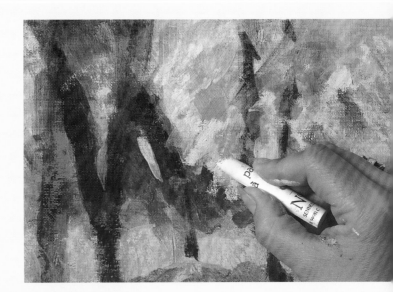

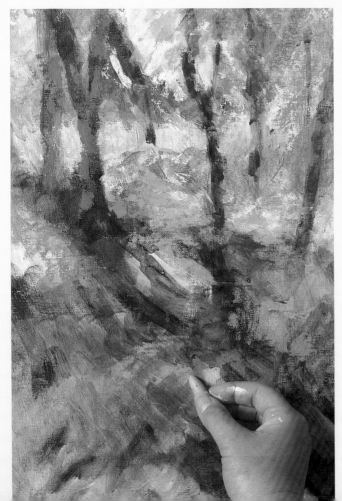

6 Transparent paint has been laid over the pastel in places, and now more pastel is applied, gradually building up the effect of dappled light by means of a layering technique.

7 This detail shows the effect of the layering method. The oil pastel acts as a resist for thin paint applied on top; you can see this in the area on the left, where the green pastel is visible through the indigo paint.

Debra Manifold
Sunlight Through Trees
The combination of transparent acrylic glazes and oil pastel has achieved a wonderful depth of colour, and the lively brush and pastel work give a sense of movement, evoking the ephemeral qualities of ever-changing light and shadow.

Buildings **Urban scenes**

All towns and cities have their own particular feeling, so if you are painting townscapes rather than 'portraits' of individual buildings, try to analyse what this feeling is, and find ways of creating a sense of place by giving visual clues. In an exotic location, for example, people's clothing and characteristic postures will be strong indicators; while in a busy modern city, you can make cars and typical 'street furniture' part of the composition.

It is often possible to convey a sense of place through colour or texture alone, making a play of light, bright colours or strong tonal contrasts in a sunny Mediterranean town, and exploiting 'low-key' colours, such as greys and browns, in a northern industrial setting. Or, you could make a feature of rough stone or peeling plaster on old buildings, or the smooth or reflective surfaces of new ones.

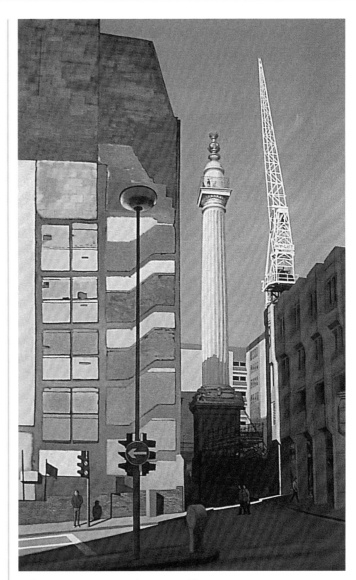

Photographic realism

In Brian Yale's painting of London's Monument and the surrounding buildings, the approach is almost photographic, with minute attention paid to every detail and texture. The composition is beautifully worked out, with the diagonal line formed by the edge of the dark shadow leading the eye up the right-hand building and the crane that forms a balance for the Monument.

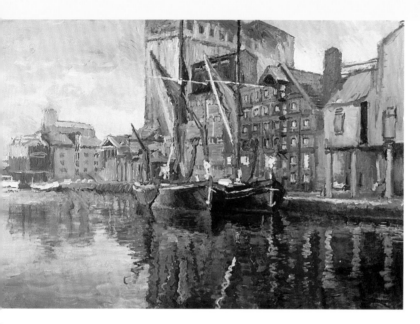

Landscape features

Gary Jeffrey's lovely painting *Ipswich Docks* shows urban landscape at its most appealing – a true marriage of man-made and natural features. The artist has worked on canvas and his painting technique is similar to an oil-painter's, with the paint built up from thin to thick, and some use of wet-in-wet techniques, particularly in the reflections.

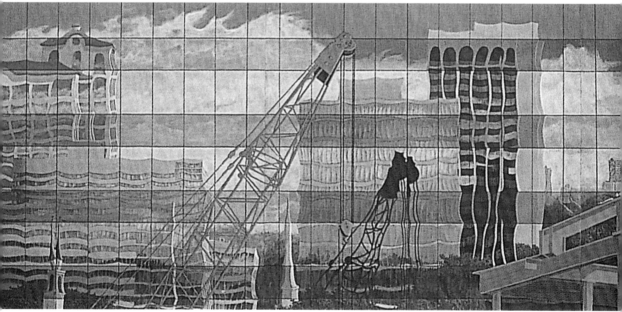

Modern buildings

One of the most exciting visual phenomena in modern cities is that of reflections in the many large expanses of glass, often distorted in intriguing ways. In *The New City*, Richard French has mimicked the effect of such reflections by using multiple layers of acrylic glazes, working on a smooth-surfaced acid-free mount board known as museum board. The painting is a large one, and to facilitate handling it was painted in three separate sections.

Continued on next page

Atmosphere

Neil Watson's *Broad Street, Oxford* is full of atmosphere and movement, the latter quality emphasized by the energetic brushwork. The paint has been used thinly – notice how it has dribbled down the board in the sky area – and some linear detail has been added with inks.

Cityscapes

Cityscapes are often avoided by amateur painters, but they can be a very rewarding subject, as Gary Jeffrey's *Spring on the Embankment* shows. He has chosen a high viewpoint, presumably from a window, which has allowed him to treat the cars as vivid patches of colour contrasting with the white slabs of the buildings.

Buildings **Individual buildings**

It is sometimes the hustle and bustle of a townscape that provides the stimulus for a painting, but some buildings invite a close, more portrait-like approach, either because they are beautiful in themselves or because they possess some striking quality of shape or texture.

If shape is the important element, you will obviously want to show the whole of the building, but texture, which can be one of the most attractive and painterly aspects of architectural subjects, can often be treated by taking a closer view and 'cropping in' so that these surface qualities become virtually the subject of the painting.

Collage

This is a technique particularly well-suited to architectural subjects, and in Mike Bernard's *Backs of Buildings, St Mary's Road, Southampton*, cut and glued paper has been used in conjunction with acrylic, inks and pastel. The varieties of paper used for collaging give an impression of textures without attempting to imitate reality. The printed-paper on the right-hand area of the foreground has been placed upside down to prevent it from being over-obtrusive.

Focusing in

In *Woman and Dark Doorway*, Jill Mirza has taken a close view and made the texture of the flaking wall and the interplay of darks and lights the joint subjects of the painting. Working on canvas, she has used the paint both thick and thin, sometimes scumbling very thin colours over much thicker applications.

Painting textures

Texture is the main preoccupation in Nick Harris's *Openings 46 – Wooden House*, and it has been portrayed with great skill. Working on watercolour paper, the artist has built up the painting in a layering technique with a succession of thin washes.

Buildings **Interiors**

The possibilities of interiors are often overlooked, but room settings provide a wealth of compositional possibilities, with the shapes of furniture and objects contrasting with the linearity of architectural features, such as doors and windows.

 An alternative approach is to paint an interior much as you would a still life, focusing on one part of the room – perhaps a mantelpiece or window. Or you can bring in an element of landscape painting, using part of the room as an 'introduction' to a view through the window, as in Daniel Stedman's painting. Light can play a vital part in the composition also. For example, light coming in through a window creates a marvellous interplay of light and dark colours that allows you to introduce a pattern element. Artificial light can also be used to advantage; a lamp casting a soft glow on surrounding objects can be the ideal focal point in an interior painting.

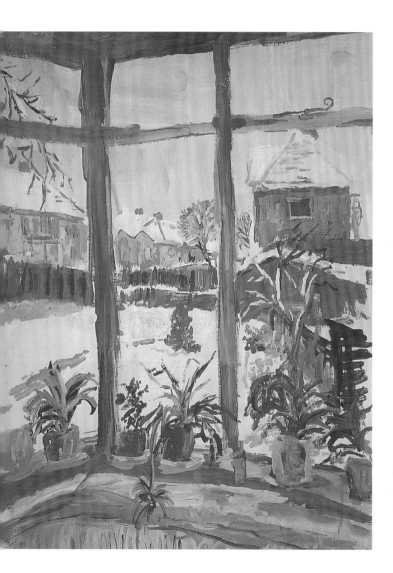

Uniting the picture planes

The 'inside-outside' theme requires careful control of tones and colours. Too much contrast in the landscape part of the painting or too little in the foreground will destroy the sense of space. Also, the painting will fail to hang together as a composition if the colours used for the inside element are too different from those of the landscape. In Daniel Stedman's *Winter Morning*, the subject has been handled with confidence – the red-brown of the house is echoed on and below the window frame, and the dark tones of the plant, bars and top of the window bring this area forwards.

Abstract values

Roy Sparkes's starkly geometric composition *Corridor to Sound Studio Under Construction* is one of several inspired by a visit to a converted wharf in Liverpool. The careful arrangement of shapes, colours and light and dark tones give the work a strong abstract quality; it can be 'read' both as an arrangement of shapes and colours and as the representation of an interior.

Painting light

Light is the major theme of this lovely painting, which is reminiscent of the works of Pierre Bonnard, one of the greatest painters of domestic interiors. In John Rosser's *Teatime View*, the view though the window is unimportant, though the window bars serve a compositional function in providing a geometric anchor for the gentle curves made by the white-clad figures.

Still life **Shapes and textures**

From a purely learning point of view, still life has many advantages. You can paint whatever you choose, arranging the group as you like to provide an interesting composition and combination of colour and shapes. But it is more than just a means of practising your painting skills; it is also a highly satisfying branch of painting.

If still life is less popular than it should be, this may be simply because the breadth of choice makes it difficult to know where to begin. Floral groups, fruit and vegetables, rich textures and reflective surfaces are frequent choices, and rewarding to paint, but many more commonplace objects can form the basis of a still life. Examples might be a pile of books on a table, a pair of shoes in the corner of a room, kitchen utensils hanging on hooks or your paintbrushes left in a jar after a working session.

Surface pattern

The cloves of garlic curving from the top to the bottom of the painting in Helena Greene's *String of Garlic* make a lively pattern of light on dark, balanced by the orange-reds of the flowers on the right. The artist has not attempted to describe the objects literally, or to mimic their textures – the painting has its own pattern and surface texture and exists independently of the subject matter.

Fruit textures

Texture plays a major role in Doreen Bartlett's delightfully simple but carefully composed *Fruit Still Life*. The smooth surface of the apple has been achieved by blending methods, overlays of colour and transparent washes, while dry brush has been used for the tablecloth and areas of the orange.

Exploring shapes

In *Siesta Time* Brain Gorst has utilised a still-life scene to explore the juxtaposition of different shapes. The artist has achieved a pleasing composition by focusing on the arrangement of the essential shapes within the bicycle and the shuttered window.

Still life **Floral groups**

A flower group, however simple, needs care in the initial arrangement and equal care in the composition of the painting. Once you have arranged the flowers, think about how you will place the group on the paper or canvas. You will sometimes find that you have a blank space at either side of the vase, and you may need to introduce some additional element to create interest in the foreground. A frequently used device is to place one of the blooms on the table beside the vase, or to scatter a few petals.

If you are painting tall flowers or a wide-spreading arrangement, you may be able to create a better composition by 'cropping', that is, allowing one or two blooms or stems to go out of the picture at the top or sides. This suggests that the group has its own life, continuing beyond the confines of the picture area, whereas showing the whole of an object 'freezes' it at a particular point in space.

Colour harmonies

Valentina Lamdin's lovely painting on canvas, *Lilac Time*, derives much of its impact from the broad mass of glowing colour, though there is also enough detail to enable the viewer to identify the flowers. The colours have been chosen with care to provide both an overall harmony and touches of contrast, and the warm pink and violets have been carried through into the background and foreground to unite each area of the painting.

Creating a broad impression

Jacquie Turner's *Bluebells and other Spring Flowers* has a similar subject matter and arrangement to Valentina Lamdin's, but the treatment could not be more different. Here the artist has taken a more impressionistic approach, expressing the brilliant colours and living quality of the flowers through an inventive use of paint and surface texture. The painting is on smooth watercolour paper, with various media such as wax crayon and chalk used with pot and tube acrylic. There are also touches of collage – small pieces of pre-painted tissue paper stuck on with acrylic medium.

Continued on next page

Unusual formats

The wide, horizontal format chosen for Mike Bernard's collage-and-mixed-media flower group has allowed the artist to make the most of the flowers and stems while reducing the vase to little more than a suggestion of a shape. The background is always an important element in still-life compositions, and in *Poppies* it has been fully integrated into the painting, with the shapes, colours and textures echoing those of the flowers.

Tone and colour

Contrasts of tone play an important part in Jeremy Galton's beautifully balanced composition. The near-black background makes the perfect foil for the glowing colour of the rose, and the dark leaves and brilliant highlights on the glass standing out against the brown of the tabletop. *The Red Rose* is a small painting, done on smooth mount board with a yellow-brown priming.

Cropping

Gerry Baptist has made clever use of the cropping device in *My Mother's Jug*, and the sense of movement is enhanced by the deliberate tilting of the jug, and the broad brushstrokes in the background that follow the direction of the stems.

Tutorial **Using a restricted palette**

A still life of fruit on a metal plate, a glass of wine and dried flowers in a raffia container provides Ted Gould with a colourful subject and an interesting and challenging contrast of textures. He has used only eight colours for the painting, since he finds that a limited palette makes it easier to achieve a unity of colour by restricting the possible permutations for mixtures. His choice of colours is: titanium white, Mars black, deep violet, cobalt blue, naphthol crimson, cadmium yellow light, cadmium yellow and chromium oxide green.

1 The painting surface is a white primed canvas, on which a line drawing was first made in yellow, followed by a thin underpainting in mixtures of crimson and two shades of yellow. The colours, mixed on a paper palette, are sprayed with water to keep them moist.

2 The paint is now made more opaque and slightly thicker by the addition of white, which had not been used previously. At this stage, more colours have been laid out on the palette, but the range is deliberately restricted.

3 The artist works from the back to the front of the painting, viewing it as a series of planes. With the dark and light tones of the background drapery in place, he can more easily assess the strength of colour and variations of tone needed in the foreground.

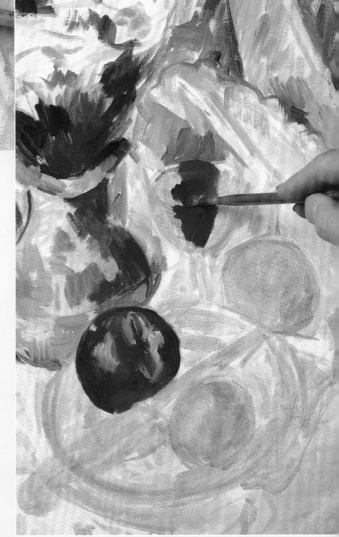

4 As he works, he constantly assesses one patch of colour against another. The reds he is using for the flowers, the wine and the nectarine are intentionally similar, since he wants to maintain a unity of colour throughout the picture.

Continued on next page

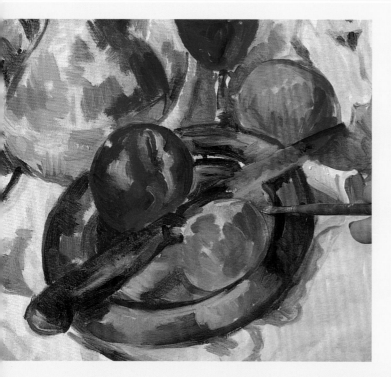

5 Further work is done on the plate with a small brush, paying particular attention to the contrast of tones and colours caused by the reflections in the metal. Notice how many different colours have been used in this area alone.

6 The most important detail is the rim of the glass, previously left unpainted in order to maintain the continuity of the drapery seen through the top of the glass. The rim is now painted very carefully with a small sable brush – ellipses are always tricky.

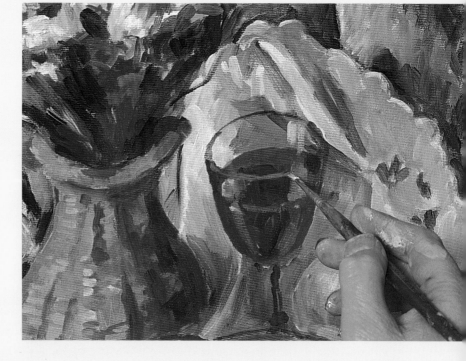

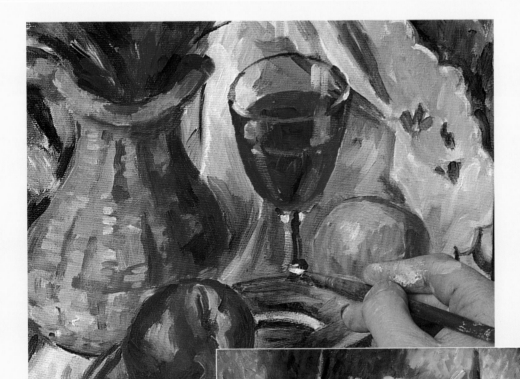

7 One of the joys of leaving the details until last is that you can save up the pleasure of putting in the highlights and seeing the whole painting come to life.

Ted Gould
Still Life with Fruit
The brushwork is vigorous as well as descriptive, and the painting glows with colour. The green of the background and the deep purplish greys of the plate and drapery provide the necessary touches of contrast to offset the predominant reds and oranges.

People **Portraits**

The primary task of a portrait is to produce a likeness of the sitter, but it doesn't end there. A portrait is a painting as well, and, therefore, to succeed in terms of art it must meet the usual criteria of composition, balanced colour and successful rendering of three-dimensional form.

It should also convey something of the character and atmosphere of the person, and a device often used by portrait painters is to show the sitter with a selection of his or her personal possessions. This can take the form of a 'mini-still life' of objects, but another approach is to paint people in their own homes rather than asking them to come to yours. The colour schemes and furnishings people choose are highly expressive of them, as are the clothes they wear.

Painting children

Children are not the easiest of portrait subjects, but can often be painted in short sessions when absorbed by a favourite activity, as in Ted Gould's charming study, *Girl Reading*. The artist has worked on canvas board, starting with a thin underpainting and building up gradually to thick impasto. He uses retarding medium to enable him to manipulate the paint for a longer period.

Head-and-shoulders portraits

In this portrait on canvas board, *Jean's Father*, Gerry Baptist has used a traditional compositional arrangement for head-and-shoulders portraits, cropping the head on the right and thus allowing more space in the direction of the sitter's gaze. The dark background accentuates the vivid red of the jacket and the bright colours used for the face itself.

Heightened colours

The hands and head at the sides of Gerry Baptist's unusual self-portrait are ambiguous: they may represent an audience – the viewers of the painting process – or they may be pointing out some misdemeanour. They also play a part in the composition, since they focus all our attention on the face, whose rich colours have been achieved by laying both opaque paint and transparent glazes over a brilliant red underpainting.

People **Figures in landscape**

Figures in landscape can be a branch of portraiture, or a figure can be used simply to provide a focal point or to explain the scale. The way you treat the figure or figures obviously depends on which approach you are taking. A distant or middle-ground figure can often be treated quite sketchily, but when the figures are in the foreground, as in both the paintings shown here, you must engage with them in more detail. However, you don't always want them to dominate the painting, so if this is not your intention, you must find ways of integrating them into the landscape.

People don't stay still for long, so you will usually have to work from either photographs or sketches, or a combination of both, but if you are making sketches with a particular painting in mind, make sure that you give some indication of both the direction of the light and the scale of the figures in relation to the landscape, otherwise you will find it difficult to integrate the two elements of the painting.

Making visual links

Ted Gould has cleverly integrated the figure into the landscape in *Woman with Cat* so that figure and trees form a continuous pattern across the picture surface. The artist appears to be more concerned with the interplay of colours and shapes than with creating space or building form – there is the bare minimum of modelling on the figure. Notice how the repetition of colours ties the figure to the landscape elements. The red of the jacket appears in the foreground flowers and left-hand tree trunk, while the dark blue of the jeans is repeated behind the figure and on the hair.

Dominant figues

In Bart O'Farrell's *Daffodil Pickers*, the figures dominate the landscape, which is treated in detail only where it surrounds and explains the activities of the men – the distant hills are merely suggested by slight tonal variations. The composition is masterly, with the first three figures forming a sharp triangle from which the eye is led along the light line of grass by the fourth tiny, crouched shape. The colours, too, are scrupulously controlled; the yellow of the garments has been 'knocked back' so that it does not stand out too strongly against the misty background.

Index

Credits

Demonstration paintings by:
David Cuthbert, Rosalind Cuthbert,
Jeremy Galton, Ted Gould, Hazel Harrison,
Debra Manifold, Judy Martin, Ian Sidaway
and Jacquie Turner.

While every effort has been made to credit
contributors, Quarto would like to apologise
should there have been any omissions or errors
– and would be pleased to make the
appropriate correction for future editions
of the book.